Brooklyn Storefronts

ILLUSTRATIONS OF THE ICONIC NYC BOROUGH'S BEST-LOVED SPOTS

JOEL HOLLAND

WORDS BY
DAVID DODGE

FOREWORD BY
KIMBERLY DREW

PRESTEL
Munich • London • New York

CONTENTS

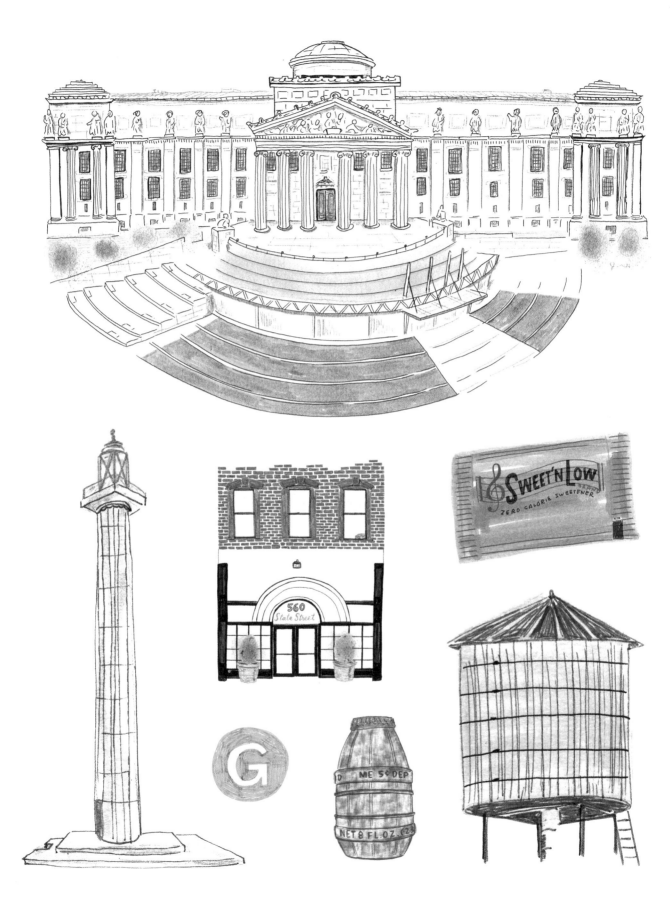

FOREWORD

If New York is the greatest city on earth, then what of Brooklyn? Long before I signed my first lease here, the borough lived in my imagination. As a kid, I first saw it through Spike Lee's lens. I screamed "*Where Brooklyn At?*" with the Notorious B.I.G. and put my lighter up with Lil' Kim. After I moved here, I found my footing as a baby gay at bars like Ginger's and Metropolitan, and later found my kin within queer nightlife collectives, including Papi Juice and bklyn boihood.

After over ten years of living in Brooklyn, I've come to know a place that is bolder than my wildest dreams. I've been able to bear witness to Brooklyn in the halls of its museums and at the cash registers of many of the businesses illustrated by Joel Holland in this gorgeous volume. As a curator, my job invites me to see the world, but nothing feeds me more than seeing these familiar storefronts upon my return. There's a tenderness in Joel's gestures that not only honor this collection of locations but, aptly, show respect for the people that work tirelessly to keep them alive.

Brooklyn is nothing without its people. It is the land of the Lenape and, today, it is home to speakers of over two hundred languages. It is Black, it is brown, it is elders, and it is multiple generations of Brooklyn natives. It is so much more than a place to be bought and sold.

I admittedly held trepidation about writing this foreword, because the borough is actively being changed by transplants like me. Over the past decade, I've watched so many storefronts come and go. I've seen my neighborhood, Bedford-Stuyvesant, be invaded. I've felt the brunt of rising rents. I've watched the horizons change. Witnessing this all firsthand is why I know it is urgent that we seek out these storefronts and support them. Brooklyn is not some backdrop. It is a community.

As transplants, it's our duty to invest in the real Brooklyn and not just the Brooklyn of our imaginations.

Brooklyn, I love you, and I know Joel does too. In this book, I hope we are spreading love the way that you know best.

Kimberly Drew is a curator and cultural critic born and raised in Orange, New Jersey. Over the past decade, she has lived in Bedford-Stuyvesant, Bushwick, and, for a brief stint, Crown Heights. She coedited the book Black Futures *with fellow Brooklyn resident J Wortham and works as a curator at Pace Gallery. You can follow what she's up to via social media @museummammy.*

INTRODUCTION

Brooklyn is a magical place. World famous. A muse. A wellspring. Even the water is famous! It's the source of so many high-quality and influential people and ideas. As a kid, I was a sponge for all of it, from the movies of Spike Lee to the music of Gang Starr, the drums of Bed-Stuy's Max Roach, and the genius designs of Paul Rand, who was born in Brownsville. And on and on.

I moved to Brooklyn (Park Place and Sixth Avenue) in 1998 and was immediately smitten. It didn't *feel like* home—it *was* home. For years, I would buy Brooklyn T-shirts as holiday and birthday gifts, featuring script lettering with a big swoop underlining it all. I remember the long-gone shop where I bought them too.

I remember my first corner store and the guys who hung out there. Every day, they would change the position of their folding chairs outside with the movement of the sun, to follow the shade.

I remember ordering a pizza from Luigi's with my friends Megan and Dolvie when they lived in Sunset Park. They said, "Ask for the special!" It came with an off-the-menu pesto drizzle topping. It was sublime.

I remember living in Greenpoint and going to Peter Pan for the first time for coffee and a donut. They had reusable plastic holders for the paper cups, the workers were in uniforms, and the donuts were incredible.

I remember visiting Coney Island for a friend's son's birthday party and thinking, "I made it!"

And I remember already wanting to go back to Roberta's literally one day after eating pizza there with Craig and Joseph.

These stories, and the stories of all who know these shops, are the lifeblood of this book. My experiences, alongside those of writer David Dodge, editor Ali Gitlow, and our local friends and associates, have guided the list of stores included. We've tried to be as geographically inclusive as possible in order to present the borough most thoroughly.

In your hands is a collection of drawings featuring over 230 of the businesses that help make Brooklyn so special. The people's borough. It's a guide and an homage. That café in Crown Heights? YES, they do nails too! Need your knives sharpened while you shop for beauty-supply products? Go to John's. What about an animatronic holiday display? I know a guy. Want a fresh bouquet of flowers? There's a great place in Bed-Stuy.

Yasiin Bey (aka Mos Def) put it best in "Brooklyn":

From the tree lined blocks to the tenements
To the mom-and-pop local shop businesses
Travel all around the world in great distances
And ain't a place that I know that bear resemblance.

Please enjoy!

—Joel Holland

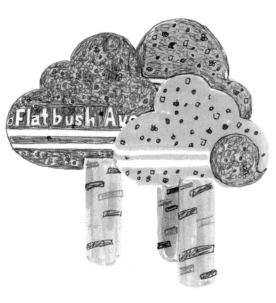

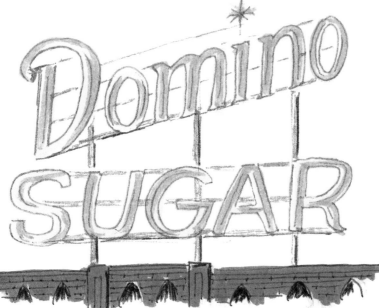

NOTE TO THE READER

Brooklyn is dynamic and ever-changing, comprised of many neighborhoods that, in all, more than 2.5 million people call home. Neighborhoods' names and boundaries thus vary according to who you ask among the borough's residents, often influenced by whether they are a native or a newcomer (or a real estate agent). This book has provided the neighborhood of each storefront to aid readers, but these distinctions are ultimately subjective. Please don't take offense if the text misplaces your favorite spot.

Care has been taken to provide up-to-date information for storefronts, but some businesses may have closed or moved addresses during the process of creating this book, and this is noted where possible.

Peter Luger Steak House

First opened in 1887 as Carl Luger's Café, Billiards and Bowling Alley, this spot is considered by many to be the best steakhouse in the city. Featuring wood-forward, bare-bones decor, the restaurant lets the meat do the talking. It once earned a Michelin star, and in 2002 the James Beard Foundation included Peter Luger's—which is among the oldest still-operating steakhouses in NYC—on its list of America's Classics.

In 2023 its owners decided to expand outside of New York State for the first time in the business's 136-year history. So, next time you find yourself walking the strip in Las Vegas, pop into Caesars Palace for a chance to enjoy a legendary prime beef steak from this Brooklyn institution.

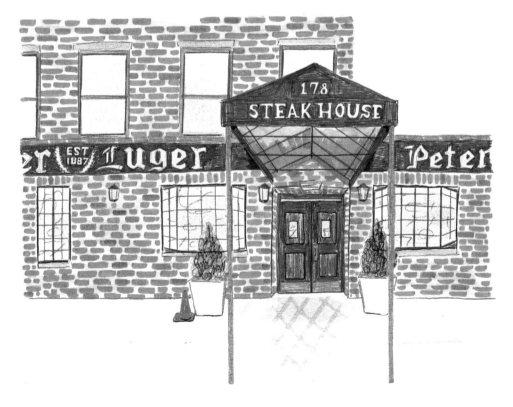

Greenlight Bookstore

When Rebecca Fitting and Jessica Stockton Bagnulo first hatched a plan to open their own bookstore after years of separately working at different independent bookshops in NYC, they couldn't get a single bank to loan them money to do so. Independent bookstores had been a losing bet for a long time, and lenders weren't willing to take the risk. So instead, they raised $75,000 by asking community members for small loans of about $1,000 each with a promise to pay everything back, with interest, within five years. In 2009 Greenlight Bookstore opened its doors and has been serving the Brooklyn community ever since.

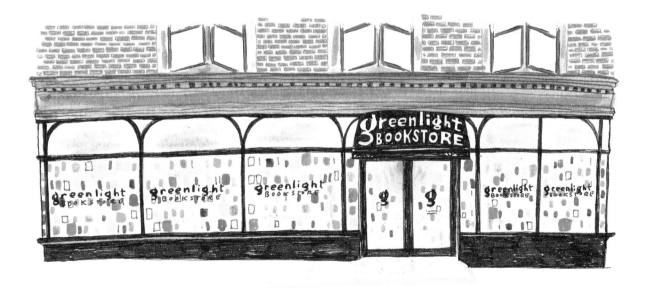

Sunshine Laundromat & Cleaners

For years this laundromat-cum-arcade was stocked with just as many pinball machines as washers and dryers, providing a welcome way to pass the time on laundry day. Now the two businesses are largely separate, save for three pinball machines in the laundry area. The rest of the games have been moved to an adjoining room, accessed through a speakeasy-esque door that looks like a washer unit. On the other side, visitors will find twenty-three pinball machines, with games that range in age from the 1980s to the present. Customers can now also enjoy wine and craft beer in this space, or get their fortune told by a mechanical monkey—all while their laundry tumble dries in the front room.

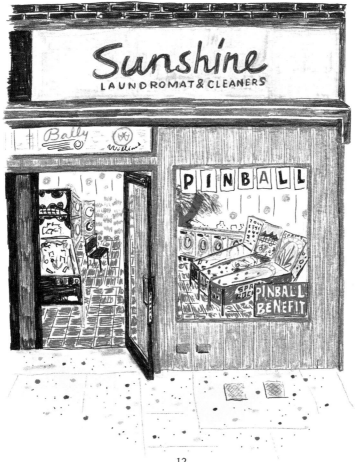

Bonnie's

———

Chef Calvin Eng, who was born and raised in Brooklyn, "grew up trying to be as American as possible," he relates on Bonnie's website. As an adult, however, he has fully embraced his Cantonese American culture through his restaurant, which he named after his mother and opened in 2022. The menu is inventive, with items like *char siu* "McRibs"—Pete Wells from the *New York Times* wrote that this dish made a "cogent statement about the long and intertwined history of American food and Cantonese food"—and a Cantonese *cacio e pepe*. The vibe, meanwhile, is raucous, aided by free-flowing espresso martinis and pitchers of Long Island iced tea made with Mexican Coke.

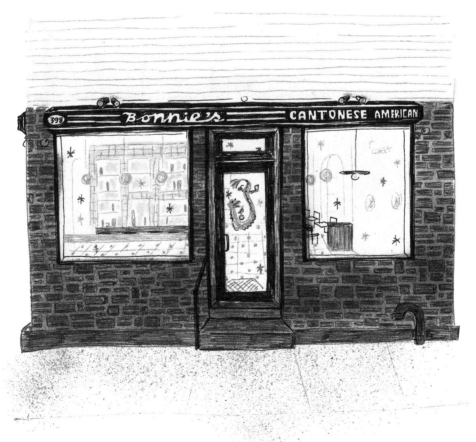

Nathan's Famous

———

In 1916 the Polish immigrant Nathan Handwerker opened a nickel hot dog stand on Coney Island. Armed with little more than a $300 loan from friends and his wife's secret spice recipe, he began laying the groundwork for global hot dog domination. While Nathan's continues to offer up its original beef franks, the restaurant has evolved with the times—their website now includes recipes for those on the keto diet.

Today Nathan's is truly famous, with restaurants around the world and products in supermarkets.

Still, the Coney Island location remains the original and is home to the beloved annual International Hot Dog Eating Contest. First started in 1972, the competition takes place each Fourth of July, awarding $10,000 and a bedazzled mustard-yellow belt to the contestants able to cram the most hot dogs down their gullets in ten minutes (without any traveling back up—what they call in the business a "reversal of fortune"). The event is now so popular it draws over thirty-five thousand in-person fans and is even televised on ESPN. The Roger Federer and Serena Williams of the hot dog–eating scene are none other than Joey Chestnut, who as of 2023 had won the competition sixteen times, and Miki Sudo, who boasts nine victories.

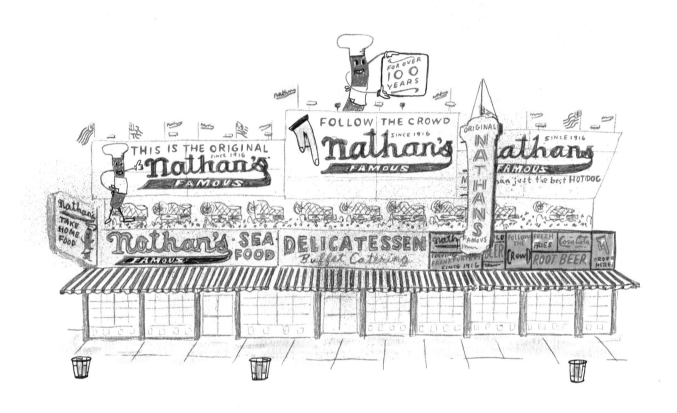

510–512 Fulton St.
Downtown Brooklyn

Bargain Bazaar Jewelry

———

This family-run store offers handcrafted luxury designs and has been open since 1991. Regulars say Iceman (which is how the shop's owner introduces himself) goes above and beyond to find clients the perfect jewelry, regardless of budget.

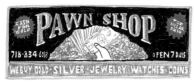

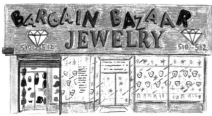

1424 Ave. J
Midwood

Di Fara Pizza

———

Domenico "Dom" De Marco opened this pizzeria in 1965, and it has been a destination for pie lovers ever since, with many ingredients sourced directly from Italy. Dom passed away in 2022, but his daughter Margie is now at the helm. There's a newer South Street Seaport location in Manhattan too.

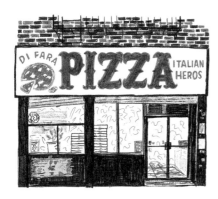

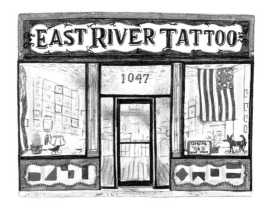

1047 Manhattan Ave.
Greenpoint

East River Tattoo

———

Duke Riley, who has been adorning skin with his ink work since 1993, opened this tattoo parlor in 2000. The artists here specialize in imagery that evokes nineteenth-century maritime folk art, and thus the studio's portfolio is filled with whales, lobsters, and other nautical designs.

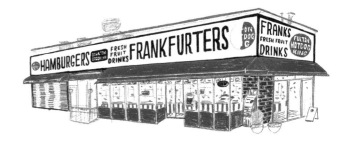

472 Fulton St.
Downtown Brooklyn

Fulton Hot Dog King

———

Located in the middle of Fulton Mall, this spot made itself hard to miss with its massive sign proclaiming "HAMBURGERS" and "FRANKFURTERS" in bold black letters. After a rent hike in 2024, the restaurant, which first opened in 1914, was forced to close. But the owner is seeking a new location in the neighborhood so he can continue serving the same menu to his loyal customers.

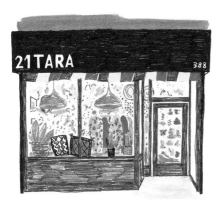

388 Myrtle Ave.
Fort Greene

21Tara

—

The owners of this textile and home-goods store are Tibetan immigrants, born and raised in refugee camps in Nepal and India. Having experienced difficult times themselves, they source products that do "as little harm as possible" to people and the environment. There's a second location on Smith Street.

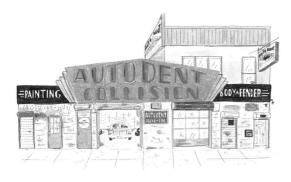

3511 Fort Hamilton Pkwy.
Kensington

Auto Dent Collision

—

Online reviews for the work of Paul Caruso III, whose grandfather opened this body shop in 1958, include words like "integrity" and "trustworthy"—a refreshing rarity in an industry with a reputation for squeezing as much out of its customers as possible.

724 Prospect Pl.
Crown Heights

Cafe con Libros

—

Cafe con Libros, which bills itself as an "intersectional feminist community bookstore and coffee shop," features a robust selection of titles by womxn authors of color, including *The Lesbiana's Guide to Catholic School* by Sonora Reyes.

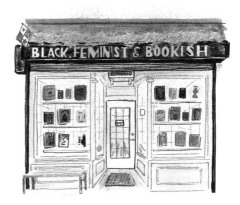

1127 Washington Ave.
Prospect Lefferts Gardens

De Hot Pot

—

This tiny Trinidadian restaurant offers takeout and counter service only. It specializes in doubles—a sandwich made from two *baras* (fried dough) filled with curried chickpea and topped with tamarind and coriander sauces—and roti wraps stuffed with oxtail, goat, or vegetables.

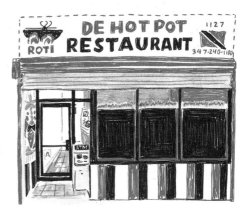

EastVille Comedy Club

———

Marko and Tia Elgart founded this comedy club in Manhattan's East Village in 2008. But in 2018, at the end of their decade-long lease and amid ongoing friction with a local community board known for being unfriendly to nightlife venues, the couple decided to move the successful business to Brooklyn. Now operating in a small 120-seat space adjacent to the Barclay's Center, they continue to host a rotating cast of up-and-coming and established comics alike. Some of the spot's better-known performers have included Jim Gaffigan, Janeane Garofalo, and Hasan Minhaj.

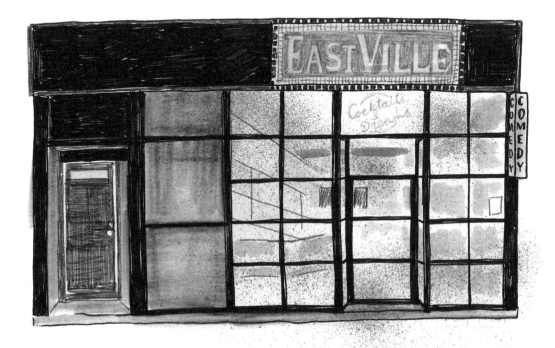

Lucali

———

Jay Z and Beyoncé once ditched the Grammys to go on a date here. David Beckham was moved to tweet about the "amazing meal" he had here. Bella Hadid celebrated her birthday here. This is not the latest Jean-Georges restaurant, however. In fact, Lucali serves nothing but pizza (and calzones), but their pies, according to the *New York Times*, are "matchless."

It's important to prepare yourself before visiting this legendary spot. A trip to Lucali—which Mark Iacono, who had never been to Italy or even made a pizza before, opened in 2016—isn't always a walk in the park. The small restaurant doesn't take reservations, and during peak hours the line to simply put your name down on the list can stretch around the corner. Ask any regular, though, and they'll assure you the hassle is well worth it. Or you can try your luck at their new Miami location.

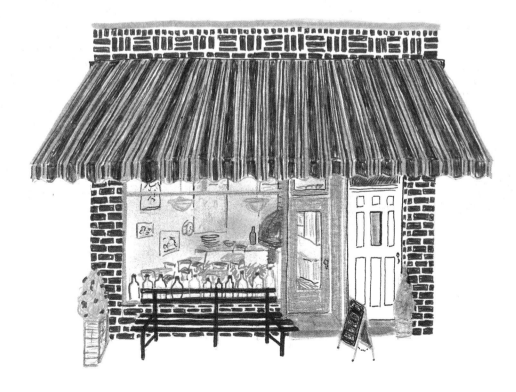

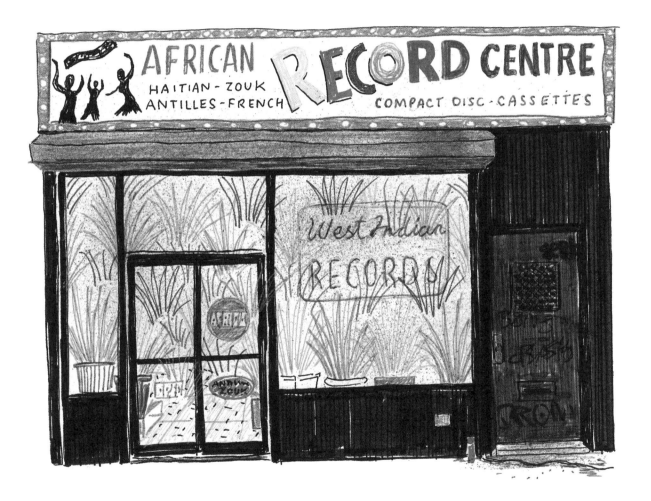

African Record Centre

——

A quartet of brothers—Roger, Rudy, Roland, and Roy Francis—opened this music store in 1969, determined to popularize African music and culture in New York and beyond. "We introduced African music to the United States," Roger said in an interview with the *New York Times*. "I will make that statement humbly but boastfully."

Boastful, maybe, but few dispute the claim: the African Record Centre was the first place in the country to stock music by legends like Fela Kuti and Franco. The brothers also created their own label, Makossa, which they ran for years out of the store's back room. The label is responsible for hits like "Soul Makossa" by Manu Dibango. (Even if you don't think you know this tune, you most certainly do: dozens of artists have sampled its iconic refrain, *ma-ma-ko, ma-ma-sa, ma-ko ma-ko-sa*, including Rihanna in "Don't Stop the Music.")

Not long after this hit, the brothers received a call from Fela Kuti, who wanted them to market his music in the States. They ended up distributing eight of his albums over the next several years, helping launch the Nigerian musician to international stardom.

From the beginning, the Francis brothers envisioned their store as a cultural hub for the African diaspora.

For many years, they operated the Yoruba Book Center next door, which sold rare publications on Black history, spirituality, and culture. They also hosted visitors from the African continent for a variety of events and cultural gatherings.

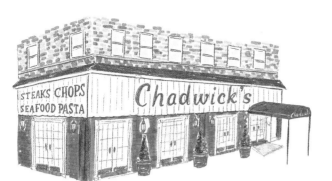

Chadwick's

———

Opened in 1987, Chadwick's is much more than a restaurant—it's also the place where countless locals choose to celebrate bridal showers, christenings, communions, graduations, and more. Co-owner Gerry Morris even hosted his wedding here.

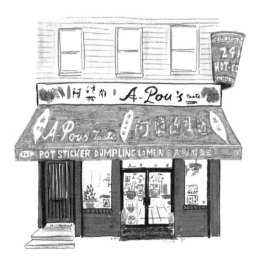

963 Grand St.
East Williamsburg

A-Pou's Taste

———

Lovingly referred to as A-Pou ("granny" in Mandarin), Doris Yao started selling food out of a street cart in 2010. Now regulars enjoy her famous potstickers at her brick-and-mortar Taiwanese restaurant, which opened in 2017.

722 Classon Ave.
Crown Heights

Park Delicatessen

———

This deli-themed storefront, run by Michael J. Sclafani and Valentine Leung, has made a name for itself thanks to its eclectic offerings. No longer must we frequent separate establishments for flowers, knitted caps, and vintage skateboards. Finally!

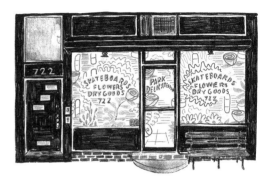

338 6th Ave.
Park Slope

Puppet Works

———

Puppet Works has been delighting children in the Park Slope community since 1980. The nonprofit's hand-carved marionettes help bring to life fairy tales like "Little Red Riding Hood" and *The Jungle Book*. Each performance ends with a behind-the-scenes demonstration.

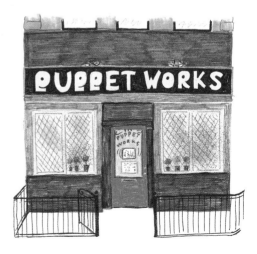

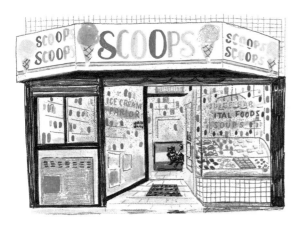

624 Flatbush Ave.
Prospect Lefferts Gardens

Scoops Ice Cream Parlor

Opened in 1984, this restaurant features a wide selection of vegan ice cream and Caribbean food. Online boards are filled with rave reviews from customers who had their first plant-based dining experience here.

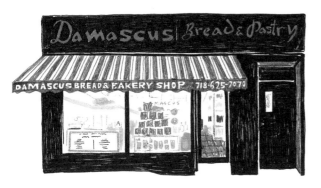

195 Atlantic Ave.
Brooklyn Heights

Damascus Bread and Pastry

Hassan Halaby opened this small Atlantic Avenue bakery in 1930. His family continued to build the business, which now produces pita, lavash, panini, and more under the name Damascus Bakeries for restaurants and stores across all fifty states.

686 5th Ave.
South Slope

Luigi's Pizza

Luigi Lanzo opened this pizza joint in 1973, and it earned the *Brooklyn Paper*'s number-one spot in a 2021 ranking, which said the shop was the best in the borough thanks to its "gobsmackingly good tomato sauce on perfectly crunchy crust." It was also featured in the 1998 Adam Sandler movie *Big Daddy*.

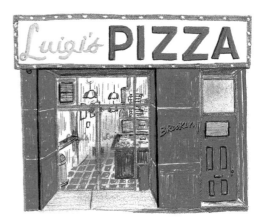

6 Suydam St.
Bushwick

Ornithology Jazz Club

This bohemian performance space, whose name refers to the scientific study of birds—and a Charlie Parker song—is a place where audiences can seek "inner flight through jazz and cocktails," according to its website.

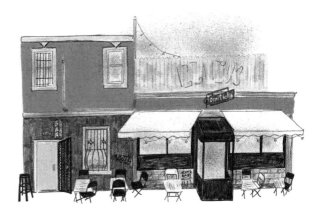

Anthony & Son Panini Shoppe

Opened in 1994, this sandwich spot started out as a grocery store but eventually became better known for its giant heroes and paninis. Regulars debate whether the best item on the menu is the Godfather—with its layers of prosciutto, capocollo, soppressata, salami, pepperoni, mortadella, and fresh mozzarella—or its wife, the Godmother, which spices things up with hot cherry peppers and fiery soppressata.

In recent years the Curcio family started posting pictures of their offerings, bursting at the seams with Italian cold cuts, cheese, and peppers, on Instagram, amassing a following of over 185,000 sandwich lovers. (According to one post, singer Kehlani counts herself among the store's fans.) Videos also demonstrate the art of assembling the massive paninis, many of them dripping with sauces and oozing with cheese.

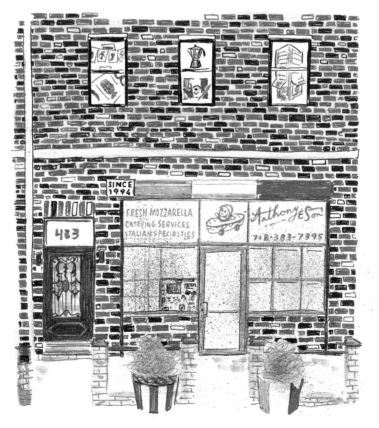

Dixon's Bicycle

In 1966 Harold Dixon, originally from Jamaica, started this bicycle shop, which sells a range of road, mountain, and hybrid bikes and accessories. His sons David and Chris run the business today and promise no bike is too rusted or busted for them to fix. "We may have to go to some prayers, or maybe up to an exorcism, which we have performed here on some bikes," Chris joked during an interview with CBS New York. "But we will make it ride."

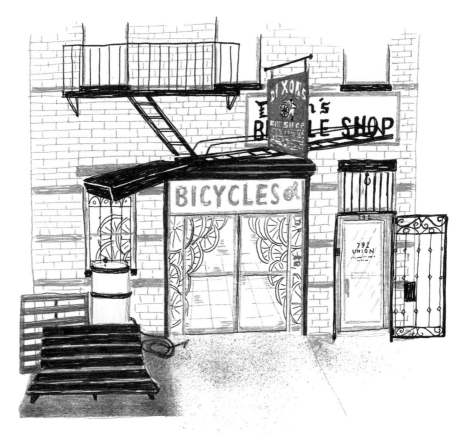

Steve's Authentic Key Lime Pie

Steve Tarpin opened this bakery in 1999 with the intention of doing one thing only—making key lime pie—and doing it exceptionally well. Over the years, though, he has introduced some innovations to his prime offering, such as the Swingle, a smaller four-inch version of his pie that's been entirely dipped in Belgian dark chocolate, served on a stick. Thanks to a special request from Steve's wife Victoria, you can also get the Swingle with a spicy chipotle puree.

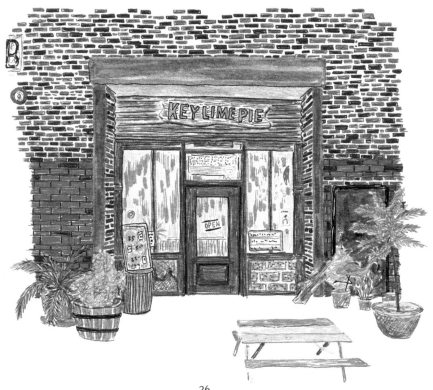

Masalawala & Sons

Spice levels are not up for negotiation at this Indian restaurant, which specializes in food from Kolkata and the larger West Bengal region. Originally located on Manhattan's Lower East Side, it hopped the river in 2022 to take up residence in Park Slope with a brand-new menu. Here, restaurateur Roni Mazumdar—who has several other restaurants around the city, including Dhamaka—stays true to the type of food he has always wanted to serve; this does not include chicken tikka masala.

Roni's goal is to transport diners to an earlier era in India. Many of the dishes are cooked in clay pots, the same way his grandmother prepared them in the 1950s. Developed by James Beard Award–winner Chintan Pandya, the menu includes items you've most likely never tried at an Indian restaurant in New York—like Ripon Street *majja* (bone marrow in *paya* sauce) and *macher pulao* (gravy-soaked fish).

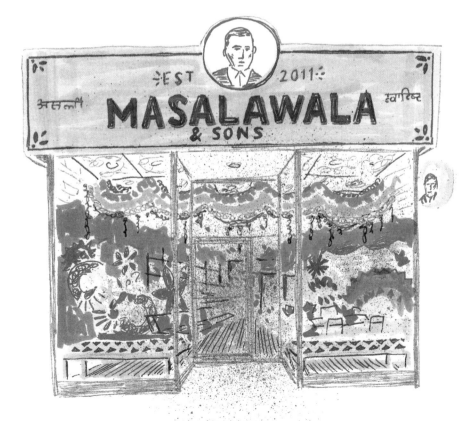

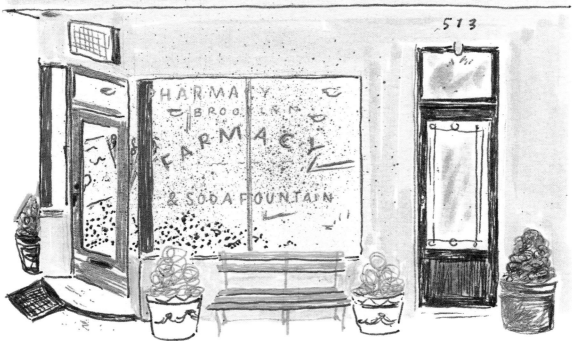

513 Henry St.
Carroll Gardens

Brooklyn Farmacy & Soda Fountain

—

When Peter Freeman and his sister Gia Giasullo took over this 1920s pharmacy in 2010 with the idea of reviving the space as an old-school soda fountain and restaurant, the project turned out to be a bigger gulp than they could swallow. The storefront had fallen into such disrepair that they couldn't even afford to fix the floor. However, a chance run-in with a producer of *Construction Intervention*, a reality show on the Discovery Channel, turned their fortunes around. Within five days, a crew of sixty helped restore the venue to its former glory.

During the renovation, the team unearthed treasures like ointment tins from the 1940s, vintage Advil and Old Spice products, and antipsychotic medications from the 1970s. To house these aged items, they bought period-appropriate cabinets and shelving. The crew also managed to preserve the antique penny-tile floors bearing the store's initial name, Longo's Pharmacy, along with the original pressed-tin ceiling.

Since opening, the space has helped revive the art of egg creams and homemade sodas, all served to customers by soda jerks dressed in 1950s-style uniforms.

Best sellers include the strawberry egg cream, made with fruit from Long Island and fresh milk from the Hudson Valley.

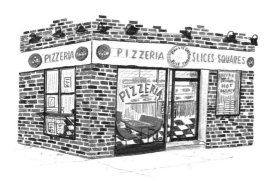

110 Franklin St.
Greenpoint

Paulie Gee's Slice Shop

—

Paulie Giannone opened this slice shop in 2010, nodding to the pizza giants that came before him, like Totonno's (p. 161) and Spumoni Gardens (p. 77), with traditional New York pies. Featuring orange laminate benches, the decor, too, is retro. But Paulie is also an innovator: the spicy honey-infused Hellboy is a local favorite, as are the many vegan options.

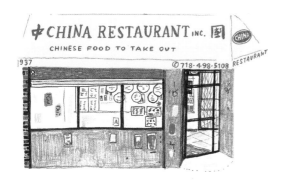

937 Utica Ave.
East Flatbush

China Restaurant

—

Featuring the words "China Restaurant" etched across its yellow awning, this small takeout restaurant doesn't look like much from the outside. But those in the know line up for a chance to try a dish so famous it has become the spot's unofficial name: the soy-soaked "Snyder Wings."

400 7th Ave.
Park Slope

Bagel Hole

—

This tiny shop is known for making bagels that are smaller than average, thoroughly baked, and topped with a reasonable but not overwhelming dollop of cream cheese—an antidote to the modern doughy variant popular at some other bagel joints.

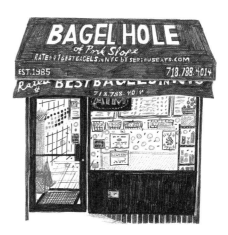

109 Grand Ave.
Clinton Hill

Van Zee Sign Co.

—

If you've passed through the painted archways at pottery studio BKLYN CLAY West or gotten your bike tuned at Two Seas Cyclery (whose logo features a pelican biking with its eyes closed), then you're familiar with the work of this shop, which has been offering custom signage and outdoor advertising since 2013.

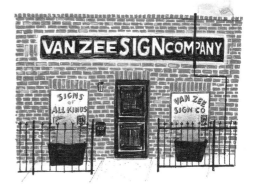

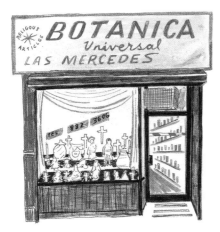

376 5th Ave.
Park Slope

Universal Botanica

—

Visitors to this botanica can purchase elekes beads, special soaps, candles, and spiritual consultations—during which you can expect to hear "what you need to hear, not what you want to hear," according to one online review.

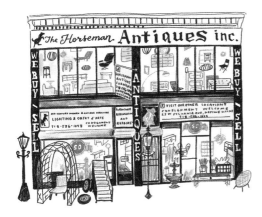

351 Atlantic Ave.
Boerum Hill

Horseman Antiques

—

Since 1962 this furniture store has been offering one of the largest collections of midcentury, industrial, and contemporary furniture on the East Coast. With five floors to explore, be sure to visit with some time on your hands.

3380 Fort Hamilton Pkwy.
Kensington

Shannon Florist & Greenhouse

—

Opened in the 1970s, this florist and plant shop has a reputation for making beautiful arrangements to accommodate any and all needs. For example, owner Joseph Perrotta once worked with a customer to create a Godzilla-themed arrangement for his uncle's wake.

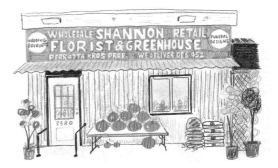

353 Union St.
Carroll Gardens

Smith Union Market

—

This family-run business, which opened in 1945, is as much a community center for the area's longtime residents as it is a market serving groceries, meats, cold cuts, and frozen foods, according to the words inscribed on its trademark red awning.

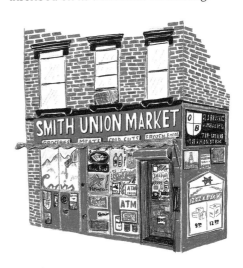

Pastosa Ravioli

———

Anthony G. Ajello began selling fresh ricotta, mozzarella, ravioli, and other Italian goods in 1966 on Avenue N and East Fifty-Third Street. In 1972 he moved the business to its current, larger site on New Utrecht Avenue and Seventy-Fifth Street. From this location, his son Michael pioneered a new line of Pastosa-branded items, including tomatoes, extra virgin olive oils, and roasted peppers. In the ensuing years, the family greatly expanded their operation, opening a dozen stores in New York and New Jersey and starting a wholesale department to supply restaurants, boutiques, and food distributors with Italian cheeses and produce.

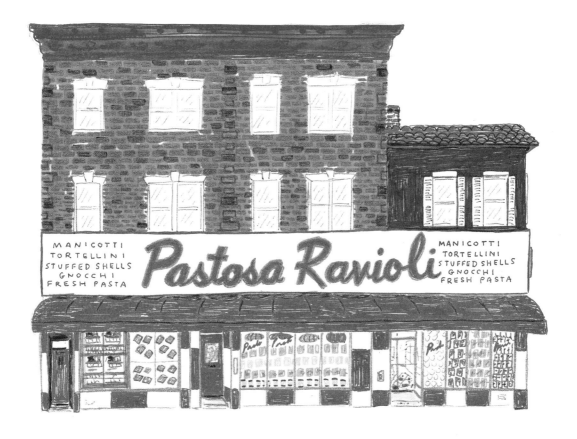

Green in BKLYN

Elissa Olin—a native New Yorker and self-described daughter of tree huggers—opened this shop in 2009 to provide customers with products and information that promote an eco-friendly lifestyle. Her store is stocked with sustainable, locally sourced, and fair-trade items ranging from towels to cosmetics to kitchen utensils. Many cleaning products come in a large vat so people can refill their own reusable containers. Green in BKLYN also regularly hosts used-book drives, compost demonstrations, recycling events, and more.

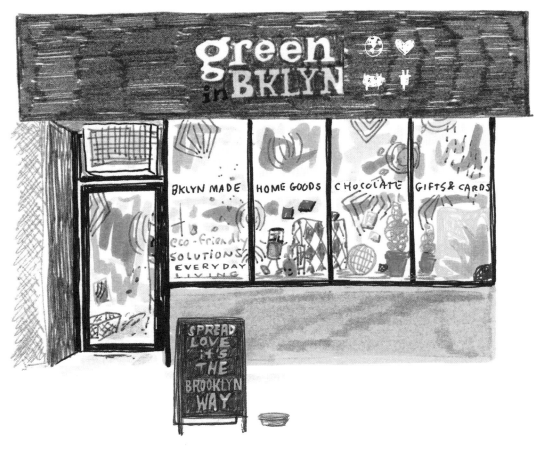

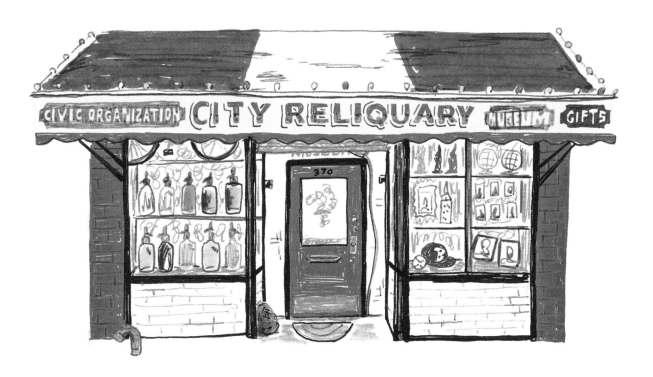

370 Metropolitan Ave.
Williamsburg

The City Reliquary

————

What began in 2002 as a display of odd objects in the windows of Dave Herman's Williamsburg apartment—like a set of dentures found in Dead Horse Bay and antique Statue of Liberty figurines, among other old-school souvenirs—has blossomed into a full-fledged museum of New York City ephemera.

The permanent exhibit here includes early subway tokens, paint chips from an L-train platform, vintage postcards, and a "very old shovel."

Temporary shows, meanwhile, explore oft-forgotten cultural milestones from the city's past. Recent offerings have included an exhibit on the Latin Quarter, a Times Square cabaret-inspired nightclub (opened, randomly, by Barbara Walters's father) that operated from 1942 to 1969. Another examined the city's infamous (and losing) battle with trash; it included photos from journalist and photographer Jacob A. Riis, who documented some of NYC's squalor during the late 1800s.

In 2017 the museum revived the historic Miss Subways beauty contest, which originally ran from 1941 to 1976 and was one of the first racially integrated competitions of its kind in the country. During its original run, posters of the contestants plastered the city's subway cars. (Notable past winners included Ellen Hart, founder of the famed Ellen's Stardust Diner in Times Square.) Building on the spirit of the original competition, the City Reliquary has updated the tradition even further, encouraging contestants of all gender identities and body types to enter.

Ayat

———

Popular Bay Ridge restaurant Ayat, which Abdul Elenani and his wife, Ayat Masoud, opened in October 2020, serves Palestinian cuisine rarely seen outside of family kitchens. The spot bears the name of Mrs. Masoud, who doubles as a lawyer when she's not whipping up recipes from her childhood, such as *m'sakhan* and *manaqish*.

According to the eatery's website, the couple is on a mission to complete "every neighborhood through Palestinian culture and tradition." Judging by how busy they've been in the last few years, this isn't just hyperbole. Since launching Ayat, the pair now own and operate multiple restaurants throughout Brooklyn, Manhattan, and Staten Island. Several of them infuse other types of food with a Palestinian flare—like Fatta Mano, a halal Italian restaurant.

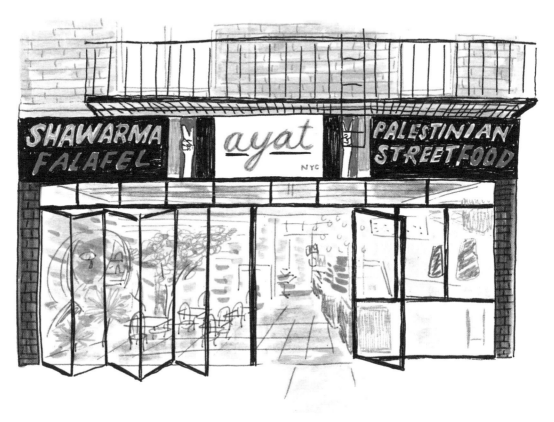

Noble Signs

David Barnett and Mac Pohanka opened this design studio in 2013 out of an "appreciation for the vanishing classic signage of New York City," according to the business's website. The duo specializes in neon, hand-painting, murals, gilding, channel letters, and more. If you've spent much time in the Big Apple, you've definitely come across some of their handiwork. The orange neon sign outside Carmelo's bar in Bushwick is theirs, as is the bright white-and-yellow banner atop the Pickle Guys' storefront on the Lower East Side.

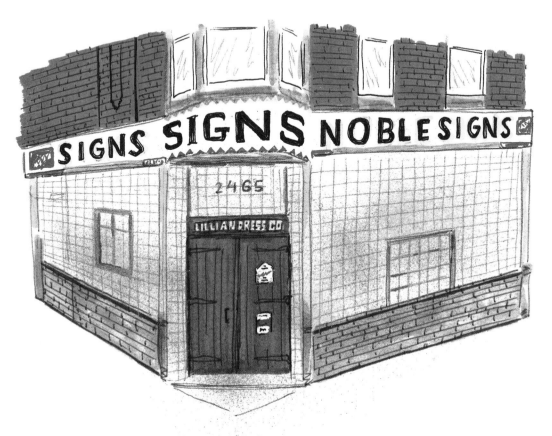

Paperboy Prince Love Gallery

———

Equal parts thrift store, gallery space, and mutual-aid center, this spot has a little something for everyone. On any given day of the week, you might pop in to find an upcycled fashion show, a "no pants" party (which is exactly what it sounds like), or a comedy gig featuring performers like local legend Crackhead Barney. Nearly all these events double as fundraisers—the shop's owner, who goes by Paperboy Love Prince, has helped raise and distribute $4 million worth of food to those in need across the city, plus they set up a free library. Paperboy's interest in bettering their community has also prompted several campaigns for political office—including for City Council, US Congress, and mayor. In 2024 they even made a go for president.

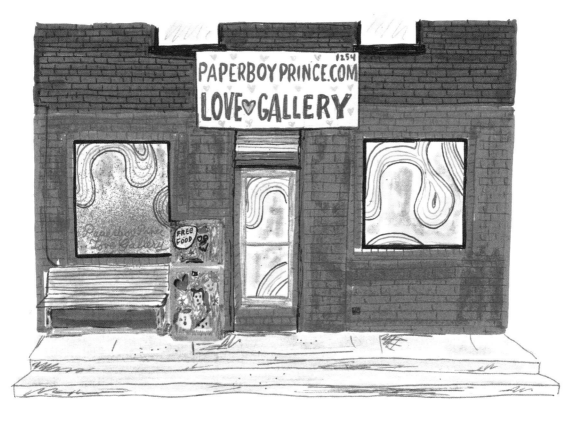

Metropolitan

———

A classic gay dive bar open since 2002, Metropolitan is where *RuPaul's Drag Race* contestants like Aja and Thorgy Thor first sharpened their stilettos. Prior to becoming a queer Brooklyn institution, the location formerly housed an Italian restaurant that earned a reputation for secretly serving wine during the Prohibition era. The current owners are doing their best to keep these subversive vibes alive by hosting parties with names like Camp, billed as a "weekly romp into debauchery and eye candy." More traditional queer bar offerings are available as well, including regular drag performances, a weekly "Queeraoke" evening, and a monthly event titled Funny Ha-Ha Funny Queer, which features up-and-coming LGBTQ stand-ups. BBQ Sundays, held throughout the summer months, are a favorite with regulars, who flock here early for a chance to snag a hot dog and a seat in the spacious outdoor patio.

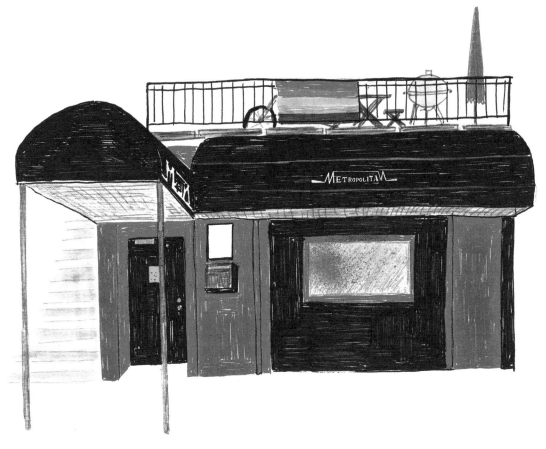

Gottlieb's Restaurant

———

Nearly every waiter at this neighborhood institution can greet you with either a hearty "hello" or a Yiddish "*hela!*" Zoltan Gottlieb, a Holocaust survivor from Hungary, opened the restaurant in 1962—which today caters to the extensive Hasidic community centered in and around South Williamsburg. Unlike the rest of uber-modern Williamsburg, Gottlieb's hasn't changed much over the years, still serving nearly the same glatt kosher menu (with six types of noodle kugel, ranging from sweet potato to salt and pepper) as when it was founded.

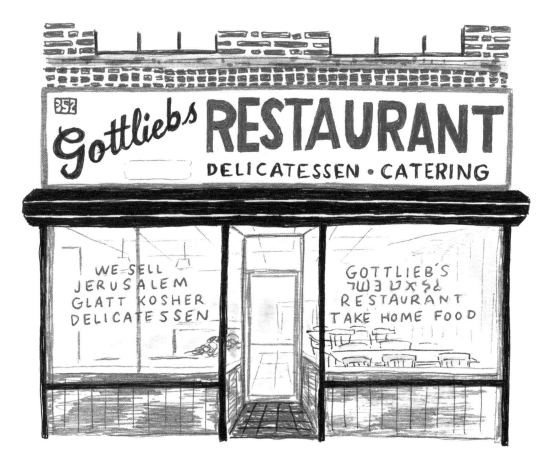

Williams Candy

———

The Williams family opened this confectionary store in 1936. Its iconic pink-and-blue cotton candy, malted milk balls, and caramel popcorn have been satisfying sweet-toothed Coney Island visitors ever since—many of whom get their savory fix from a hot dog from Nathan's Famous (p. 14), located right next store. But the Granny Smith candy apples, which they call "jelly" apples since the coating is so soft, are the real king here—the shop sells up to four thousand a week.

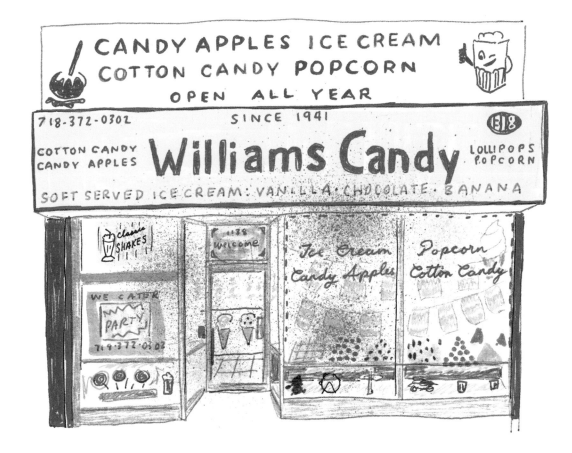

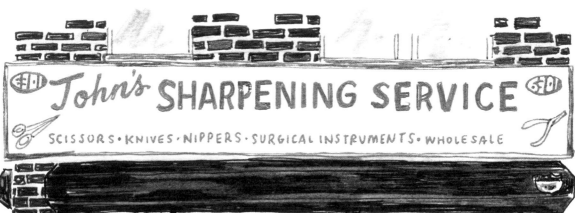
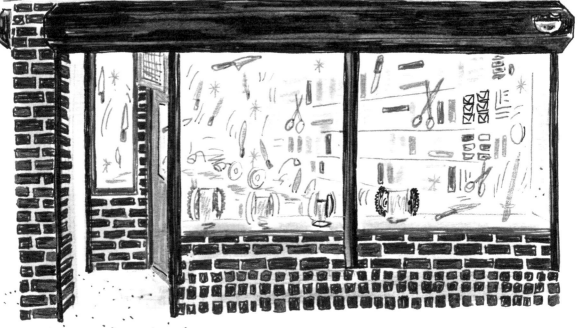

6301 10th Ave.
Dyker Heights

John's Sharpening Service

———

Knives too dull? This storefront is the place to have them sharpened—and while you're here, feel free to pick up a double-ended curette or a pair of serrated forceps. The backstory of this odd blend of businesses starts with John Bianco, who opened his sharpening spot in 1972. He was also a hairstylist (who took part in competitions against the likes of Vidal Sassoon) and owned and operated several salons in Brooklyn. As a third side hustle, he started Bianco Brothers out of the same shop at the crossroads of Dyker Heights and Borough Park to create and sell beauty, dental, and podiatry products.

Both businesses have their share of quirky regulars, including Wendy Blades, a Coney Island sword-swallowing performer.

"I trust them with the tools that I use for my art," she told the *New York Times* in a profile about the storefront, "But really, they help me not die." Other regulars include hairdressers, barbers, butchers, manicurists, plastic surgeons, dog groomers, and more.

After John passed away in 2009, his three sons—Vinnie, Joe, and Dominic—took over the business and are working to honor his legacy. "The hardest part of the craft is the feel of it," Joe told NPR, explaining the advice his father gave him as he prepared for his turn at the helm. "It's through guidance that you get the feel. Like, 'Lift up that elbow, turn that hand. Hold that file differently. Pick up your shoulders. You're gonna have to do this for thirty years, you can't be slouching.'"

540 Metropolitan Ave.
Williamsburg

Desert Island Comics

Gabe Fowler applies an "abstract idea of punk rock" to his book and comic shop, according to Desert Island's website. Contributors to the store set their own prices, and their works are sold on a consignment basis, with revenues split between the store and artist.

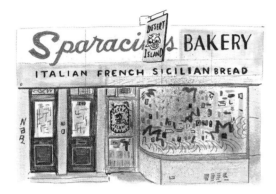

1449 Nostrand Ave.
Flatbush

Nostrand Donut Shop

A luncheonette-style diner, Nostrand Donut Shop is a throwback, down to its high-top counter seating and Formica tables. Despite the name, it offers much more than donuts. Regulars don't bother placing orders here, as staff remember on sight.

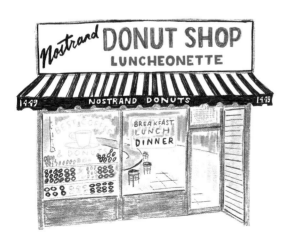

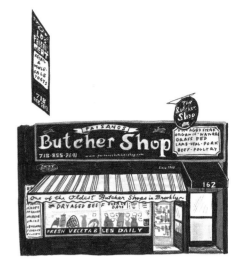

162 Smith St.
Cobble Hill

Paisanos Butcher Shop

This butcher shop, a family-run business founded in 1960, sells dry-aged steak, Italian sausage, and organic meat—and is the "best reason" to live in the neighborhood, according to an online review.

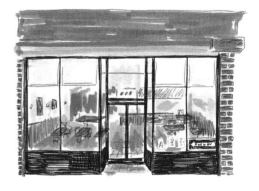

415 Tompkins Ave.
Bedford-Stuyvesant

Peaches HotHouse

This Bed-Stuy restaurant specializes in Nashville-style hot chicken (fried chicken coated in enough cayenne pepper to clear the sinuses). Its owners also run three other Brooklyn eateries serving up different types of Southern food.

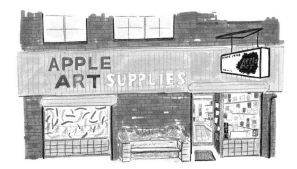

321 DeKalb Ave.
Clinton Hill

Apple Art Supplies

—

Opened in 1940 (under the name Jake's), this art-supply store once counted Patti Smith as a regular customer. In her memoir *Just Kids*, she wrote that she and then-partner Robert Mapplethorpe often struggled to decide whether to spend what little money they had at the time on food or colored pencils.

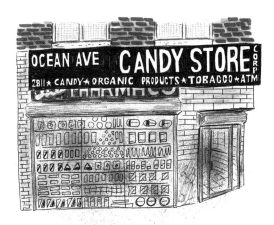

2811 Ocean Ave.
Sheepshead Bay

Candy Store Corp.

—

Despite its name, this shop is more of a traditional New York deli than a candy store. Sure, you can get plenty of sweets here—but you can also pick up organic products and tobacco, as the classic black-and-white awning proclaims.

496 Flatbush Ave.
Prospect Lefferts Gardens

Fulani Boutique

—

A. B. Bah (who customers affectionately referred to as "AB") opened this boutique in 1991 to create custom clothes and provide expert tailoring services to the Brooklyn community. Since AB's death, his wife and children have operated the store, keeping his legacy alive.

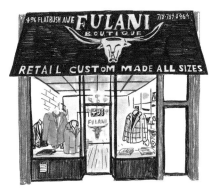

5905 4th Ave.
Sunset Park

Full Doe Bakery

—

It's still possible to get a filling breakfast for less than a cup of Starbucks coffee at this popular bakery, which one online reviewer referred to as a "precious piece of Southern China." Arrive early in the morning, before the freshly baked buns run out.

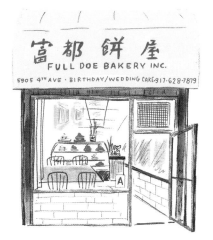

Das Upholstery

———

This upholstery shop is bursting with such a chaotic collection of furniture and fabric that, at first glance, you could mistake it for the living room of your hoarding great aunt. If you ask Das Chunilall, the store's owner, where he's from, he'll say, "Heaven." (He's not though, he's from Guyana.) But according to dozens of online reviews, his work is angelic, particularly his attention to detail. One client looking to reupholster a loveseat using a bee-print textile collaborated tirelessly with Das to ensure the bugs were flying in the right direction.

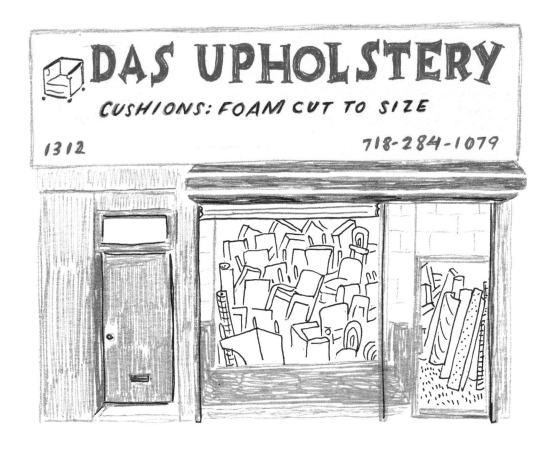

House of Yes

———

Kae Burke and Anya Sapozhnikova—who, in addition to being best friends, are long-standing circus producers—opened House of Yes in Ridgewood, Queens, in 2007 as a place to host aerial and burlesque classes and events. It was a "hippie-punk squat house," according to the venue's website, "complete with hallways filled with trash, leaky ceilings, and curious odors." It was the perfect home, Kae and Anya decided, for some freaky circus stuff.

The duo lost their first space due to a fire, and their second to a rent increase. They moved to their current Bushwick location in 2015: a five-thousand-square-foot site for circus acts, cabaret performers, nightclub events, and whatever other spectacles tickle their fancy.

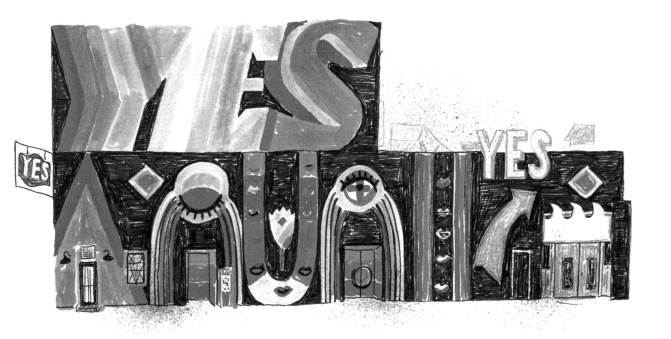

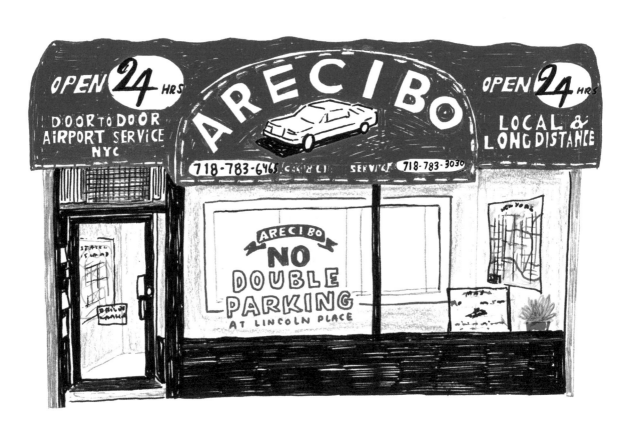

Arecibo Car Service

Eons before Uber was even a glimmer in Garrett Camp's eye, there was Arecibo—and the Brooklyn-based car service is still shuttling riders around the city.

Are taxis in Manhattan refusing to take you to an outer borough? Arecibo is at your service. Want a reliably cheap ride to John F. Kennedy Airport? Give that 718 area code a ring. Need a car equipped with seats for your newborn? Arecibo has you covered. And for at least one online reviewer, this company is way better than some of the unmarked cars patrolling the outer reaches of Brooklyn offering rides. "Arecibo to stay alive I say," he wrote.

For years, upon calling the company, customers would be placed on hold while attempting to be connected to a driver, where they were treated to the instantly recognizable riffs of a smooth jazz guitar playing the same five-second earworm on a loop. The song was the stuff of internet fodder—both positive and negative. "The Arecibo hold music should be the national anthem of Brooklyn," proclaimed one Twitter user in 2011. "The worst way to break up with someone (in Brooklyn) would be over the phone and then play the Arecibo hold music when they call back," wrote another customer. Alas, in 2016—to the great consternation of its fans, and even some of its foes—the business updated its music. However, the tunes don't matter as much these days: to stay competitive with app-based car services, Arecibo has greatly reduced the amount of time customers stay on hold.

2939 Cropsey Ave.
Gravesend

Parkview Diner

———

Just north of Coney Island, this greasy spoon serves up traditional diner fare, like omelets, soups, and burgers—and delivers the "best food I can eat while being sick," according to one online reviewer.

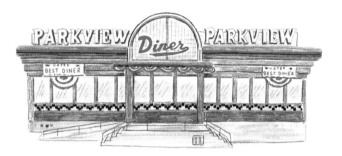

7 Newkirk Plaza
Ditmas Park

Ol' Time Barbershop

———

For over a century a barbershop has existed at this address in Newkirk Plaza. The plaza was built in 1907, making it the oldest still-operating outdoor shopping center in the country.

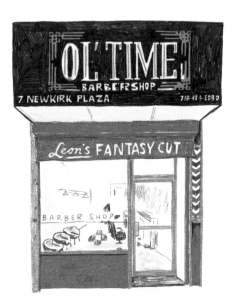

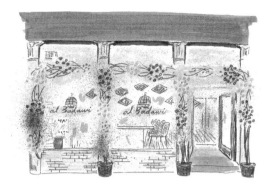

151 Atlantic Ave.
Brooklyn Heights

Al Badawi

———

After opening the restaurant Ayat in Bay Ridge (p. 36), co-owners Abdul Elenani and his wife, Ayat Masoud, founded this Brooklyn Heights spot to help spread the knowledge that "Palestine does have a culture, . . . and Palestine does have very good food," as Abdul told the online publication Brooklyn Magazine.

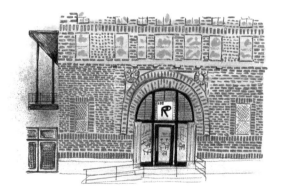

233 Butler St.
Gowanus

Public Records

———

Shane Davis and Francis Harris opened this multifaceted venue in 2019 to celebrate the intersection of music, design, and food. The listening bar and club spaces are outfitted with high-end audio equipment used by a rotating cast of international DJs and performers, and the restaurant offers a completely vegan menu.

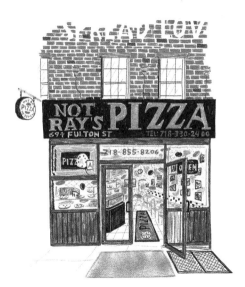

694 Fulton St.
Fort Greene

Not Ray's Pizza

It's an ongoing debate: Which of the many famous Ray's Pizzas in New York City is the original? Helpfully, this Fort Greene spot—known for heaping every available inch of its specialty slices with toppings—has made it abundantly clear it's not this one.

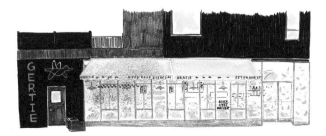

357 Grand St.
Williamsburg

Gertie

This hip restaurant bills itself as a "Jew-ish" diner. The menu offers freshly baked bagels, deli sandwiches, and classics like latkes and matzo ball soup, and customers are invited to linger with a tipple from the "day drinking" menu. Gertie's owners run a second Brooklyn eatery, Gertrude's, located in Prospect Heights.

Floyd Bennett Field
Barren Island

Gateway Camp Store

Situated on the outskirts of Brooklyn, Camp Gateway welcomes campers and RVs alike, and it is among the few places to (legally) camp within New York City limits. The on-site store offers firewood, drinks, food, and basic camping supplies.

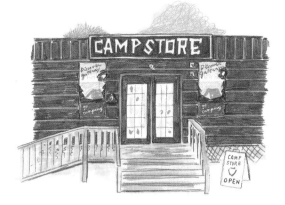

7 Franklin St.
Greenpoint

Pop's Popular Clothing

This workwear store, open since the 1940s and at its current Greenpoint location since the 1990s, sells jumpsuits, thermals, and parkas that are made to last. The shop offers a large selection of Carhartt clothing—known for its ability to withstand the demands of manual labor, and recently made uber trendy with the hipster crowd.

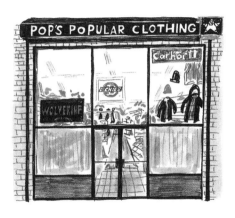

Bamonte's

———

This Italian restaurant has been serving up its classic red sauce since Pasquale Bamonte, an immigrant from Salerno, first opened its doors in 1900. The business remains in the family, and they've kept the menu largely consistent over the years—a comfort to those who want their clams casino or eggplant rollatini prepared the same way each time.

The dining room similarly hasn't changed much since the 1950s, with its ornate chandeliers and heavy red drapes. Now, however, in addition to featuring pictures of the pope, its burgundy walls are adorned with signed portraits of celebrities like James Gandolfini, who filmed several episodes of *The Sopranos* here. It's said that Bamonte's has been a favorite hangout for real-life mobsters as well, who, rumor has it, insisted on the restaurant having a glassed-in open kitchen (unusual for the time it was built) to ensure no one was poisoning their food.

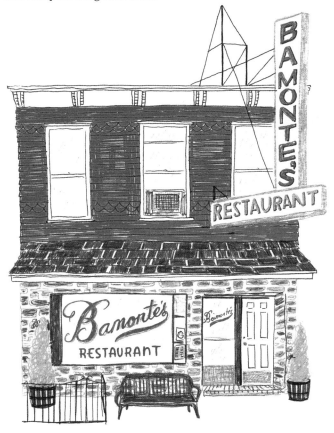

Dobbin Street Vintage Co-op

A group of vintage and antiques enthusiasts have co-owned and operated this business since 2016. It offers unique and affordable furniture, clothing, and more, mostly from the 1960s through 1980s. The original co-op members met at the Brooklyn Flea (the borough's largest flea market), where they rented booths for their individual enterprises. When the Flea relocated, the sellers decided to go in together on a project of their own. It has since taken off; in 2022 the *New York Times* included the storefront in its popular 36 Hours travel column. In addition to this location in Greenpoint, the crew opened a second spot in Williamsburg.

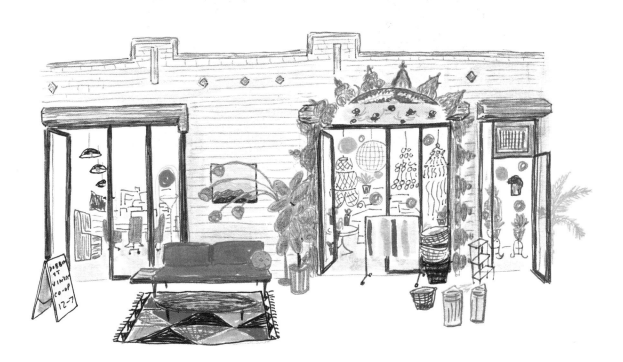

Twenty Sided Store

—

As Twenty Sided says on its website, "May you roll crits!" If you know what that means, then this place—which hosts Dungeons & Dragons gatherings and other events, and has an active Discord channel for its regulars—is for you. Also, in case you're in the market for spiked ball dice made with steel, or mini sets made from marble, it proudly boasts the largest selection of dice in New York City. In addition to stocking board games and D & D, the store developed its own role-playing games, called Twenty Sided Adventures. The storefront shown here closed in 2023, but their other space on the same street is still very much in the game.

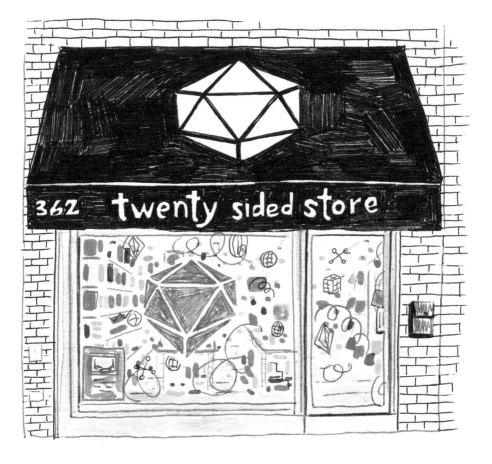

Landi's Pork Store

In 1928 John J. Landi began working at this butcher shop—originally located on Navy Street—and bought it during the Great Depression, rebranding it Landi's Pork Store. The business thrived under his watch, earning John the nickname "The Sausage King" (a phrase he eventually trademarked).

Following an initial move during World War II, in 1959 he relocated the store to its current spot in southeastern Brooklyn. Here, John expanded his offerings into Italian food, producing fresh mozzarella and homemade ravioli and manicotti. His sons Ben and John later began making precooked meals that customers could warm up at home—an innovation that ultimately required the enterprise to expand into a new five-thousand-square-foot warehouse. Today the business is run by the third Landi generation, John Jr. and Danny, who continue to offer popular precooked specialties, including baked ziti, chicken parmigiana, and stuffed eggplant.

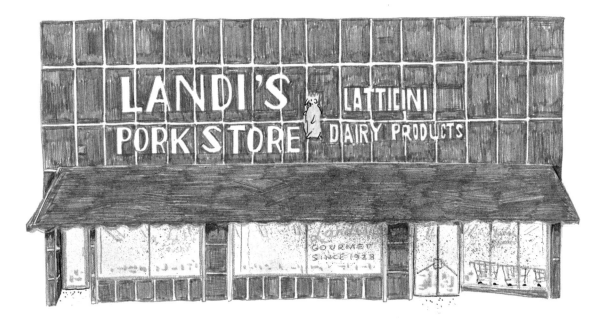

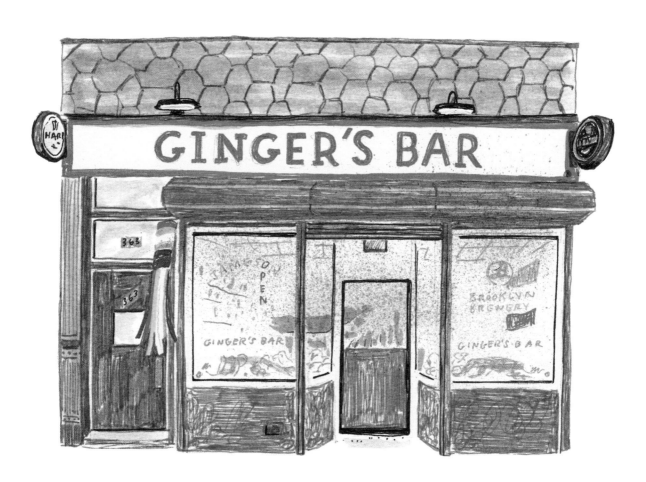

363 5th Ave.
Park Slope

Ginger's Bar

———

The bathroom walls at this lesbian bar are lined with pictures of queer icons like Jane Lynch and pretty much the entire cast of the original *L Word*. When Sheila Frayne first opened Ginger's in 2000, it was one of several lesbian-friendly spots in Park Slope—a neighborhood more affectionately referred to by those in the community as "Dyke Slope."

Today it's the last-standing lesbian watering hole in the area, and its devoted patrons aim to make sure it'll be around for years to come.

The space, in fact, has long-standing LGBTQ roots. Before its current incarnation, it was home to a bar mostly catering to gay men called Carrie Nation, named after the temperance activist who famously busted open barrels of booze with an axe at establishments that served alcohol.

During the Covid-19 pandemic, Ginger's shut its doors for nineteen months. Regulars feared the closure would be permanent, as was the fate of many LGBTQ bars at the time. However, Sheila managed to crowdfund more than $24,000 from her loyal customers to remain operational, and in a rare case of landlord generosity, the property's owner even forgave all the back rent she was unable to pay while closed. Today Ginger's continues to thrive—so much so that Sheila and her business partner Brendan Donohoe were able to open an East Williamsburg location, Mary's, in 2023.

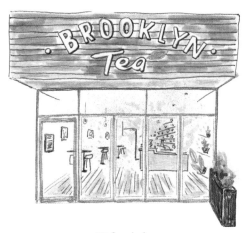

411 Lewis Ave.
Bedford-Stuyvesant

Brooklyn Tea

—

In Jamaican households, "tea is life," according to Alfonso Wright, co-owner of this shop. "You wake up to tea. If you have a sneeze, a cough, or your ankle hurts, tea is always the cure," he told the website Black-Owned Brooklyn. And the cure is working: Wright has expanded across Brooklyn and to Atlanta too.

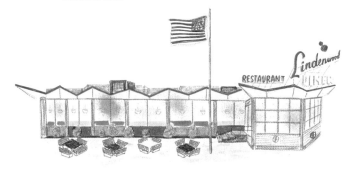

2870 Linden Blvd.
East New York

Lindenwood Diner & Restaurant

—

Instantly recognizable thanks to its iconic red-and-yellow neon sign, this old-school restaurant offers traditional American diner fare with Latin and Caribbean influences— like steak and eggs with a side of tostones, and omelets with a helping of fried yucca.

194 Flatbush Ave.
Park Slope

Versailles

—

Clothing boutique Versailles specializes in custom wedding, party, and prom dresses. "If you can think it, they can make it," according to one online review.

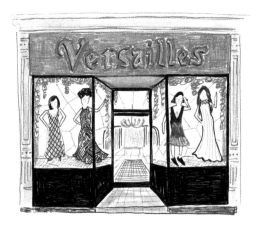

601 Vanderbilt Ave.
Prospect Heights

White Tiger

—

In 2015 restaurateur Chelsea Altman and her designer brother, Ben Altman, opened this Korean eatery with chef Liz Kwon. Regulars say not to leave without trying the deviled eggs, made with creamy fish-roe mayo.

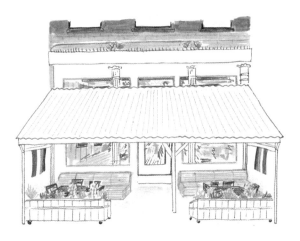

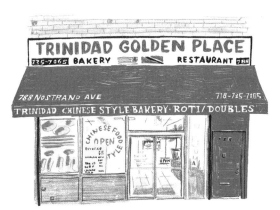

788 Nostrand Ave.
Crown Heights

Trinidad Golden Place

—

Get here early: this popular Trinidadian bakery often has a line of regulars eager to purchase its coconut rolls, raisin buns, and goat roti before supplies are gone for the day.

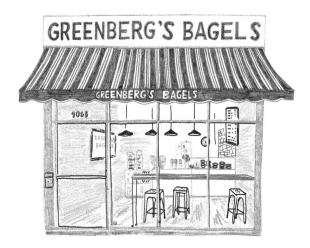

1065 Bedford Ave.
Bedford-Stuyvesant

Greenberg's Bagels

—

Julian Cavin—who opened this Bed-Stuy bagel shop in February 2020—is known for his innovations, like jalapeño-cheddar cream cheese and pizza bagels. His personal preferences, however, skew more traditional. "I like sesame, or everything, or plain," he told the website Brooklyn Magazine.

295 Grand St.
Williamsburg

The Four Horsemen

—

This Michelin-starred and James Beard Award–winning restaurant, co-owned by James Murphy of the dance-rock band LCD Soundsystem, has one of the most extensive lists of natural wine in the country.

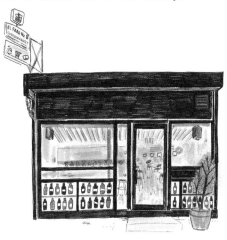

1063 Bedford Ave.
Bedford-Stuyvesant

Valentine's Pizza

—

Pop into Valentine's for a slice but don't leave without inquiring about the specials—which might include a ham-and-cheese breakfast bun, banana-pepper pizza, or a chocolate-chip "pizza cookie." It's run by the team at Greenberg's Bagels, which sits right next door.

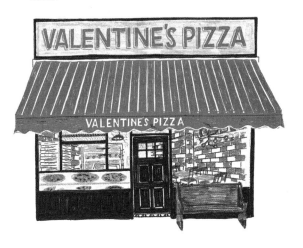

Stone Avenue Library

Opened in 1914, originally as the Brownsville Children's Library, this neighborhood institution is thought to have been the first library in the world exclusively devoted to serving kids. Andrew Carnegie funded the project, and William B. Tubby designed its castle-like facade to look like something out of a fairytale. In 2014 the city renovated the building, which now features a life-size chess set and a "Word Wall" mural depicting the one thousand most common words in the English language.

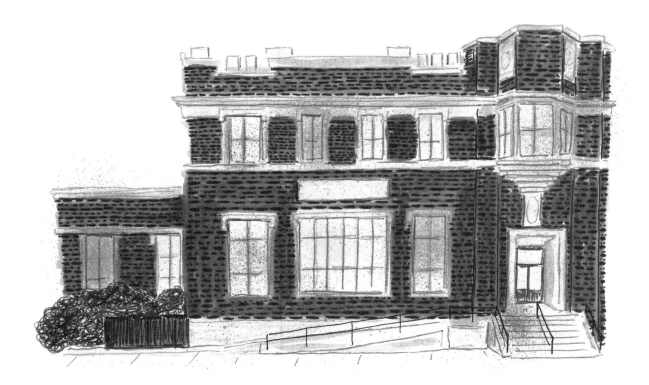

327 Nostrand Ave.
Bedford-Stuyvesant

Dept. of Culture

———

Small Nigerian prix fixe eatery Dept. of Culture made a splash soon after opening in 2022, earning a nomination for best new restaurant from the James Beard Foundation and rave reviews from outlets like Eater and the *New Yorker*. Owner and chef Ayo Balogun cooks in an open kitchen, carefully explaining the roots and significance of each dish to diners as they are served while an antique record player plays Fela Kuti and other Nigerian-born artists. The space is Ayo's attempt to re-create Nigeria's casual dining venues known as *bukas*. In coming years he hopes to invite guest chefs to help give customers a broader taste of the diverse cuisines in Nigeria—a country with over 250 different ethnic groups. "I already have some aunties lined up," he told the *New Yorker*.

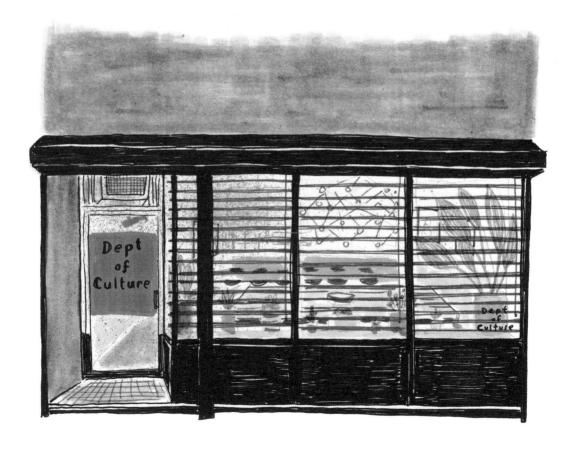

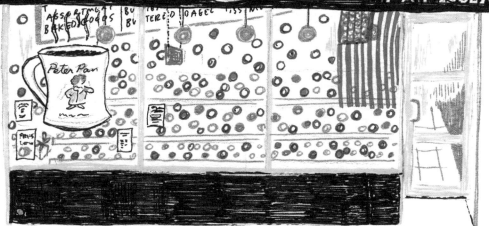

Peter Pan Donut & Pastry Shop

If you ever find yourself in Greenpoint at 4:30 in the morning in search of a Bavarian cream donut, Peter Pan, which opens at this ungodly hour, has got you covered.

It offers dozens of goodies that recall an "age before trans fats," according to *New York* magazine. Donna and Christos Siafakas, the bakery's current owners, purchased the space in 1993. They were inspired to start their own business after first meeting at a different donut shop in Queens, where she worked as a waitress and he as a baker.

The store looks much as it did when it first opened its doors in the 1950s, down to the black-and-white-checkerboard floors. As a preserved throwback, it's an in-demand spot for location scouts, too, having hosted scenes in the Vince Vaughn movie *Delivery Man* and the NBC series *Shades of Blue*. And, although the staff's mint-green and pink cuffed uniforms look vintage, they are actually new—a modern flourish based on bakery outfits Christos saw on a television show.

A beloved neighborhood spot, Peter Pan also operates as something of a "yenta center," according to one regular interviewed in the *New York Times* in 2016. "They don't kick you out," the octogenarian said. "You don't see people for a while, and they come in with good news or bad news."

Viola Pigeon Club

———

When the United States entered World War II, Frank Viola enlisted in the army and donated his flock of pigeons to the cause, training the birds to carry messages across enemy lines. After returning home, Viola made a name for himself throughout the 1940s as one of the country's best homing-pigeon racers—a sport that was all the rage following the war. Until his death in 2007, he hosted the Frank Viola Invitational, a prestigious contest requiring pigeons to travel four hundred miles from Ohio to New York.

In the 1950s he founded his racing club, for which he purchased thoroughbred pigeons (often for thousands of dollars each) and then trained them to compete. Though they are the same species as the street birds most New Yorkers are familiar with, these are decidedly not those birds.

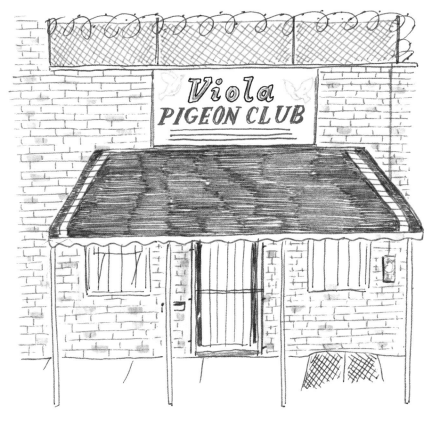

Lords Bakery and Photocakes

This bakery, which opened in the mid-1950s and sadly closed in April 2024, was known first and foremost for its red velvet cake—which shouldn't come as a surprise, since the spot included a giant image of it on its signage. Regulars, however, said the blue velvet version was a close second.

In more recent years, Lords made a name for itself by printing any image (including book covers, magazine photos, cartoons, and more) on the cake of customers' choosing. *Good Morning America*, for instance, once came to these experts to emblazon the likenesses of Diane Sawyer and Charles Gibson across a cake to celebrate the duo's fifth anniversary as hosts of the show.

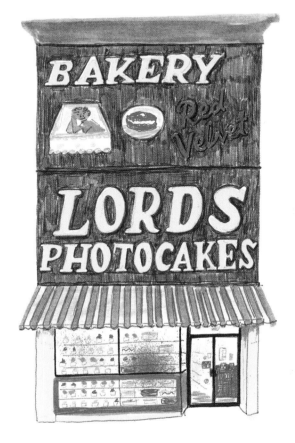

The Bad Wife

———

In 2010 Jim Lee renamed his long-standing bodega the Bad Wife, sparking a heated debate in online comments sections. "The name of the store drew me in," wrote Niki, one reviewer. Others, like Rob, said they have "assiduously avoided" the shop due to its "ridiculous name." Jim isn't much bothered by the controversy, he explained in an interview with the *New York Post*, because the name is simply an inside joke between him and his wife, Sungki—who is a "queen," he said, as well as an incredible wife and mother.

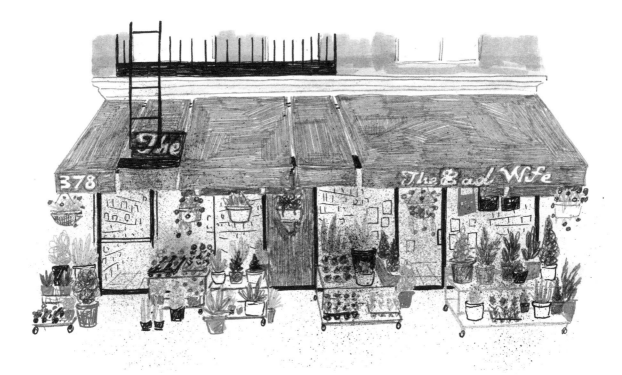

The Long Island Bar & Restaurant

Ramon Montero opened this bar and restaurant in 1951; soon after, his daughter Emma and her husband, Buddy Sullivan, took over and ran the business until 2013. That year, Joel Tompkins and Toby Cecchini—the latter of whom holds the claim of having created the modern version of the Cosmopolitan cocktail while working at TriBeCa's famed Odeon restaurant in the late 1980s—bought the spot and renovated it, taking great care to preserve the Art Deco interior. The duo also restored the neon sign adorning the building's facade, which had been broken since the 1970s.

The bar here continues to top many "Best Of" drinks lists thanks to its short but distinctive menu, which includes a Boulevardier that reminds customers why it's "one of the world's greatest cocktails," according to *New York* magazine's food blog Grub Street.

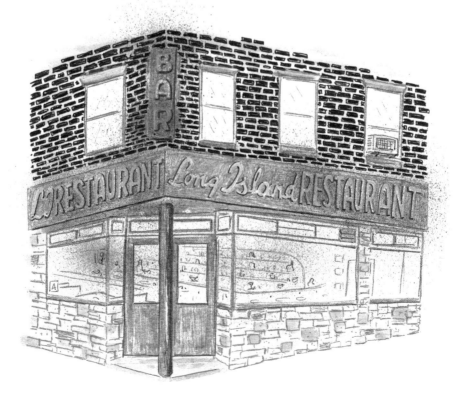

The Exley

———

Historically most queer bars, by definition, have been dives—safe spaces for LGBTQ people to gather and be with one another. As social acceptance has grown, however, queer folks now have less need to meet in secret spaces with drinks capable of fueling a jetliner. Enter the Exley, a watering hole catering primarily to gay men that swaps out bottom-shelf vodka sodas for concoctions like the Garden Party (a cocktail made with vodka, cantaloupe, Lillet Blanc, and lemon) and the gin-and-jalapeño-based If I Only Had the Nerve. Still, if you're feeling nostalgic for the old-school fire-breathing tipples of the gay bars of yesteryear, the bartenders will be happy to oblige.

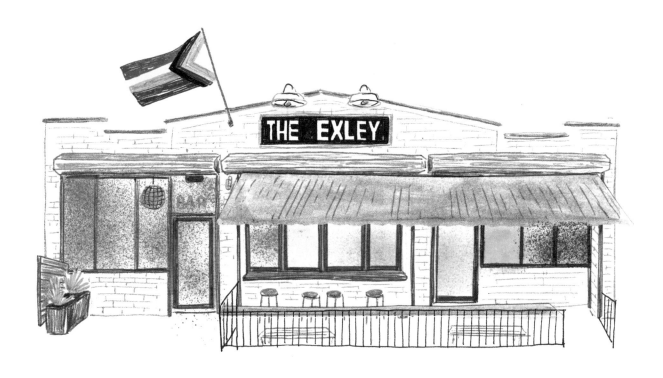

Clemente's Crab House

––––

At Clemente's, only the occasional JFK-bound plane overhead reminds diners in this Maryland-style eatery that they are, in fact, still feasting on seafood in New York City. The crab house, first opened in 2002, is located on the outskirts of Sheepshead Bay, offering serene views of Gerritsen Beach and a boat-filled marina.

Though Clemente's boasts a full menu of seafood items, it's the piles of freshly boiled crabs—accompanied by wooden mallets and plastic bibs—that keep customers coming back. Most of the restaurant's crabs come directly from Maryland. Order yours "Clemente style" and you'll be treated to an extra dose of roasted garlic and oil. Co-owner Jimmy Muir has deep roots in the seafood business: for years his grandfather Teddy Clemente ran a popular stand at Manhattan's Fulton Fish Market.

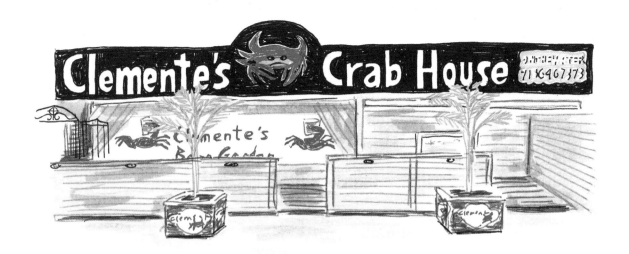

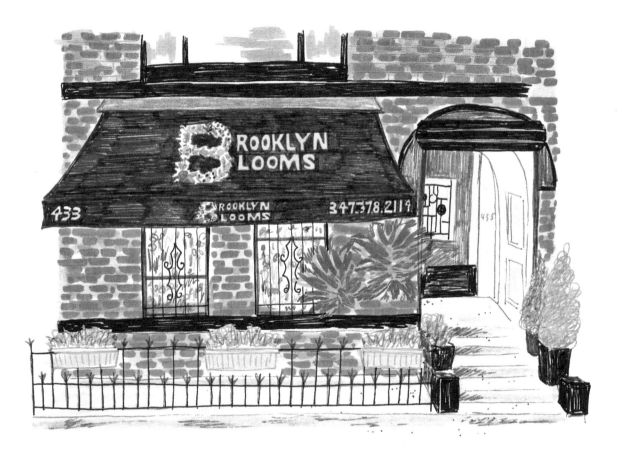

Brooklyn Blooms

———

LaParis Phillips opened her first floral studio on Nostrand Avenue in Bed-Stuy in 2017. It became so popular with locals that she expanded to a second location in the neighborhood in 2021. The love is clearly mutual, as many of her arrangements are named after the surrounding streets. The Malcolm X is "extra large, low, and lush," while the Marcy is a "one-sided style arrangement created in one of our hand-picked vintage vases."

After originally pursuing a career in fashion, LaParis switched to the floral industry and brings a similar eye for colors, silhouettes, and textures to her creations—which she describes as "funky, textural, and carefree." She also works with sustainability in mind. "It's nature that gives me my livelihood," she said in an interview with *Luxe Interiors + Design*, "so it's my duty to honor that." She forgoes plastics and foam bricks in her packaging, instead opting for second-hand vases or even thrifted objects like handbags as vessels in many of her designs.

LaParis's arrangements are full of Afrocentric inspirations, including hand-painted designs on palm fronds in the style of traditional West African mud-cloth patterns.

"A lot of people tell me, 'I can tell these flowers were done by a Black girl,'" she told the website Black-Owned Brooklyn. "There's some spice to it."

188 6th St.
Gowanus

Acme Dog Run

All Matt Majesky ever wanted as a kid was to have a dog, but he was so allergic that his parents refused. Now, however, as the owner of Acme Dog Run, a four-thousand-square-foot indoor playground he opened in 2019, Matt spends his days surrounded by pups (presumably with the aid of allergy pills).

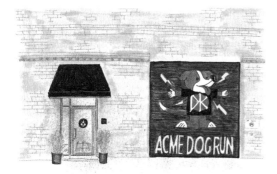

95 Broadway
Williamsburg

Marlow & Daughters

Andrew Tarlow opened this whole-animal butcher shop in 2008 to provide grass-fed, high-quality meat to his Brooklyn-based restaurants, including Marlow & Sons, Diner (p. 89), and Roman's, as well as the wider neighborhood.

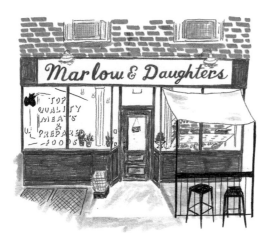

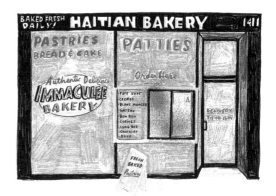

1411 Nostrand Ave.
Flatbush

Immaculee Bakery

The family-owned Haitian bakery Immaculee is widely known as the place to get pâtés, or patties—savory, flaky puff pastries commonly filled with beef, chicken, or fish. In a rush? Walk up to the storefront's window and get 'em to go.

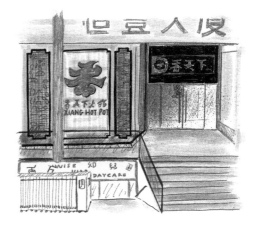

5816 Fort Hamilton Pkwy.
Sunset Park

Xiang Hotpot

Hot-pot spot Xiang is known for its "spicy bear" broth, which comes with an edible butter bear taking a cozy bath in a spicy Sichuan broth. The owners also run a second location in Flushing, Queens.

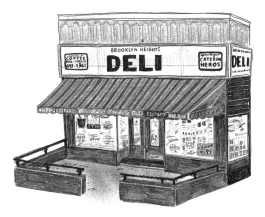

292 Henry St.
Brooklyn Heights

Brooklyn Heights Deli

—

This spot has all the trappings of a traditional New York City deli. Those in the know regularly stop in for some of the most popular (and cheapest, according to reviews) sandwiches in the area.

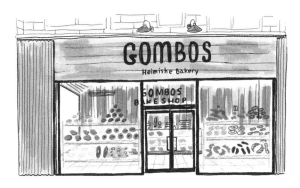

328 Kingston Ave.
Crown Heights

Gombo's Heimishe Bakery

—

Gombo's Heimishe Bakery offers up what the website Gothamist described as a "sweet tooth's dream," with an impressive selection of cookies, cupcakes, donuts, and four different types of hamantaschen fillings (chocolate, apricot, raspberry, and poppy) for your next Purim celebration.

5922 New Utrecht Ave.
Borough Park

Savarese Italian Pastry Shoppe

—

This pastry shop has been around since 1918, when the Savarese family immigrated to Brooklyn from Naples. Though a bakery first and foremost, with Italian goodies like *sfogliatelle*, *pasticiotti*, and tiramisu, regulars say not to leave without a scoop of gelato.

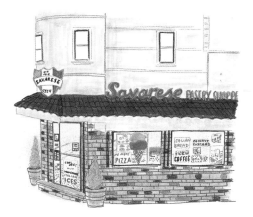

254 S. 2nd St.
Williamsburg

L'Industrie Pizzeria

—

This beloved slice shop serves classic pies here (and at a second spot in Manhattan) with some modern twists, like the mozzarella-based pizza with fig jam, bacon, and ricotta.

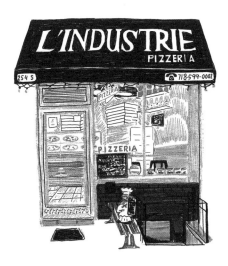

Pecking House

———

After cooking together at the prestigious Manhattan restaurant Gramercy Tavern, Eric Huang and Maya Ferrante opened this hot-chicken spot as a pandemic-era pop-up in 2020, originally only offering takeout and delivery. To make the business's trademark delicacy, they brine chicken in buttermilk, cover it in a five-spice powder, and manage to keep it crunchy even after a commute thanks to a wheat dextrin called EverCrisp.

Today Pecking House welcomes in-house diners as well, but make sure you plan in advance. There's often a weekslong waiting list.

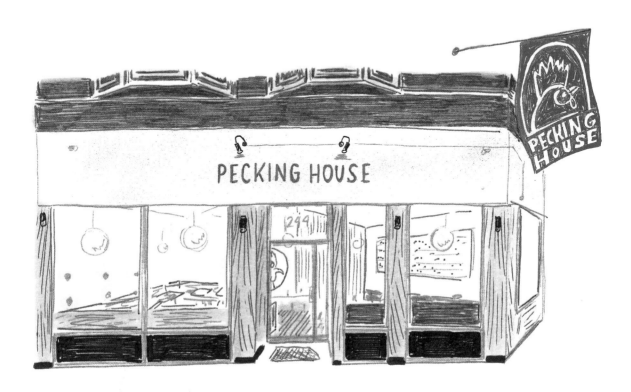

International Food

———

In 2022 Bobby Rakhman changed the name of this deli, known for decades as Taste of Russia, to protest the invasion of Ukraine. He removed the market's long-standing sign— which featured the domes of St. Basil's Cathedral in Red Square in Moscow—as part of the rebrand. Bobby unveiled the new moniker, International Foods, shortly after; it better captures the store's offerings, which include specialty foods from across Eastern Europe. The revamped name is intended to be "inclusive of our entire immigrant population, rather than just Russia," according to Elena Rakhman, the store's co-owner and Bobby's wife.

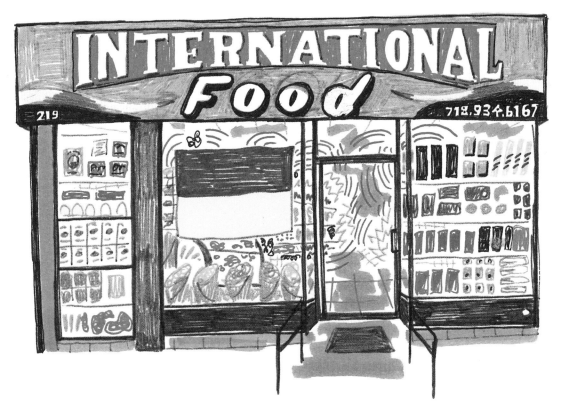

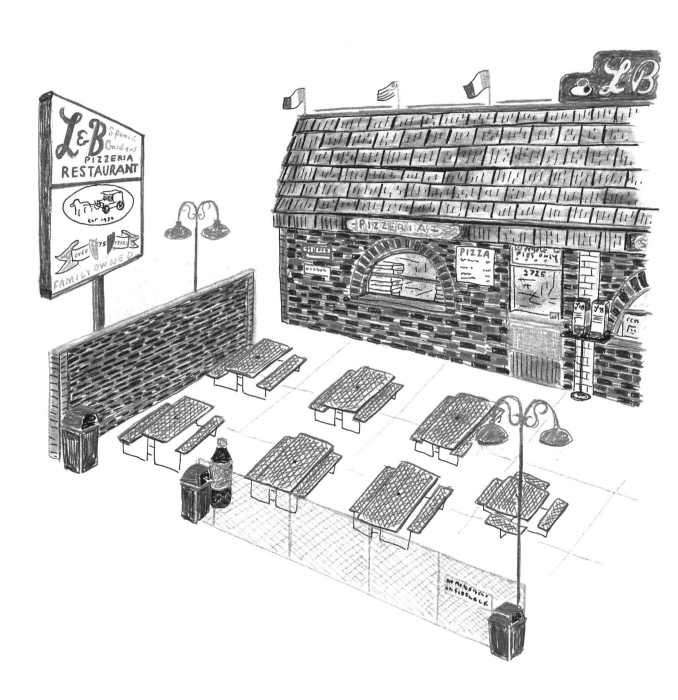

L&B Spumoni Gardens

———

After immigrating to the United States from Italy in 1917, Ludovico Barbati started selling pizza and spumoni, a trilayer gelato traditionally made with fruit and nuts, on the streets of southern Brooklyn from a horse-drawn wagon (the horse was named Babe). Ludovico opened this storefront on Eighty-Sixth Street in 1939, and in the 1950s he expanded to include a pizzeria, ice cream parlor, and red-sauce Italian restaurant.

The businesses are housed in three interconnected buildings, but the space's iconic outdoor seating area—complete with bright red picnic tables—has helped make L&B Spumoni Gardens a beloved summer hangout for generations.

Get there early during the warmer months, as spots outside can be hard to come by. And, though it's best known for its to-go slices and ice cream, lovers of Italian food should try Spumoni Gardens' sit-down dining room, resembling a "rococo fever dream," according to the online review site the Infatuation.

The Brooklyn institution also has had its share of celebrity endorsers. Model Bella Hadid once snapped a selfie enjoying a scoop or two of the restaurant's ice cream. And in 2023 *Saturday Night Live* alum Pete Davidson handed out pies to picketers during that year's writers' strike. "I got Spumoni's for everyone," he said in a clip that went viral, adding, "Gotta support the writers, man!"

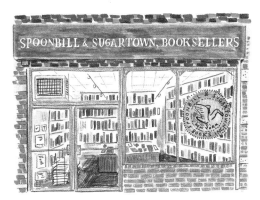

218 Bedford Ave.
Williamsburg

Spoonbill & Sugartown Booksellers

———

Looking for a book about the history of New York's grid system, or a signed copy of *Plane Debris* by poet Stephen Rodefer? This store—which opened in 1999 and specializes in used, rare, and new books on art, architecture, and design—is your spot.

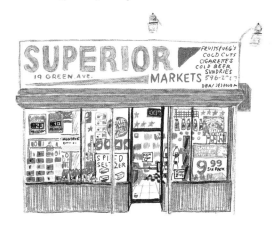

19 Greene Ave.
Fort Greene

Superior Markets

———

Regulars trek to this neighborhood institution for a cup of coffee or a sandwich, and to chat with the friendly staff. As one online reviewer put it, "If you're looking to support a local, family-owned business and shoot the shit while you're at it, look no further."

954 3rd Ave.
Sunset Park

Tire Factory

———

It's hard to miss this auto shop with tires piled six feet high on the sidewalk outside. The workers here have developed a reputation for changing flat tires at lightning speed—one online reviewer said the entire job was done in under ten minutes.

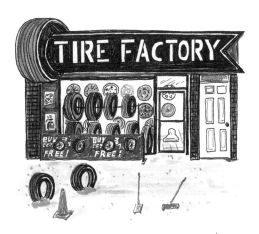

725 McDonald Ave.
Kensington

TrainWorld

———

Open since 1968, TrainWorld sells—you guessed it!—hundreds of model trains. Here you'll find options from starter wooden sets to electrical offerings, as well as figures from the children's television show *Thomas & Friends* and the Christmas book-cum-movie *The Polar Express*.

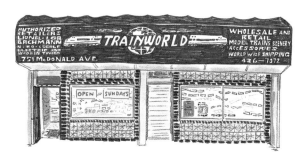

335 Smith St.
Carroll Gardens

Brooklyn Social

—

Brooklyn Social first opened its doors in 2004 in the former space of the Society Riposto, a Sicilian men's club that began meeting there in 1967. Many of the bar's decorations, including framed photos of the society's original tux-clad members, remain the same.

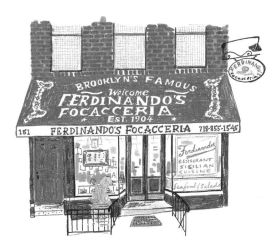

151 Union St.
Carroll Gardens

Ferdinando's Focacceria

—

Opened in 1904, this restaurant is the oldest still-operating Sicilian eatery in New York. Though its menu has evolved over the years, it continues to offer a focaccia sandwich, popular in Palermo in the early 1900s, stuffed with cow spleen, ricotta, and caciocavallo cheese.

563 Gates Ave.
Bedford-Stuyvesant

Maya Congee Cafe

—

According to one online reviewer, the congee bowls at this Asian grocery—which also sells sandwiches, specialty drinks, and spices—"smack so much" they were willing to forgive the establishment for running out of farro. Clinton Hill is home to a second location.

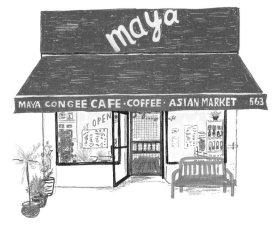

1463 Fulton St.
Bedford-Stuyvesant

Savant Studios

—

In 2019 Michael Graham opened this boutique, where he sells his clothing line. His designs, many of which feature colorful textiles made with dyes and leathers sourced from the Yucatán, have earned him loyal fans, including the actor Zendaya.

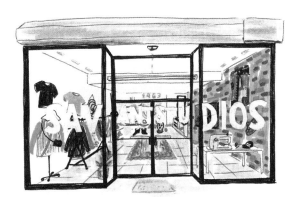

The Sultan Room, Turk's Inn, and Döner Kebab

———

The Sultan Room, a 201-person-capacity music venue, is the arabesque-themed oasis of your dreams. It's hosted inventive club nights like Home & Abroad, a dance party featuring DJs playing Afrocentric tunes accompanied by live drummers. The space is also a favorite among indie acts like Thelma and the Sleaze and Delicate Steve—but whomever you come to see, be sure to arrive early to dine at the adjoining restaurants, the Turk's Inn, for some wagyu steak tartare and kebab-shop calamari, or Döner Kebab, for a kebab heaping with lamb and beef.

The spot is an ode to a famous, now-defunct Turkish eatery that opened in Hayward, Wisconsin, in 1934. When owners Varun Kataria and Tyler Erickson (who are Wisconsin natives) learned the restaurant's belongings were to be auctioned off, they hopped on the next flight and scooped up its iconic neon sign, original bar, and other invaluable tchotchkes, and set about re-creating the space in Bushwick.

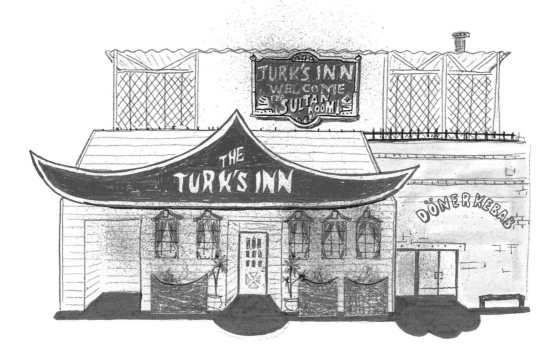

Pies 'n' Thighs

Sarah Sanneh and Carolyn Bane first met while working as cooks at the celebrated restaurant Diner in Williamsburg (p. 89). In 2006 they opened their own eatery nearby that specializes in comfort food, like chicken and waffles and bourbon pecan pie.

The restaurant has quickly evolved into a neighborhood institution in its own right. This is the place to come when you're in the mood for something decadent. The butter pecan crunch donut has the "radius of a soup bowl and the potency of a sticky bun," according to a *New York Times* review. And Pies 'n' Thighs is regularly listed among the city's best fried chicken spots.

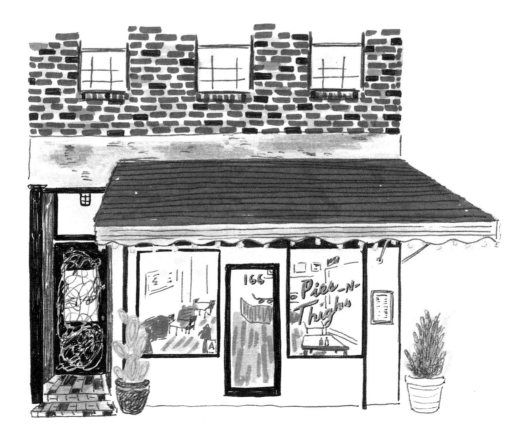

Iris Lingerie

Known by regulars as the "bra whisperer," Iris Clarke has been fitting women of all sizes with brassieres and corsets since first moving from Belize to Brooklyn in the 1970s. After a decade-long stint at Bloomingdale's and a period designing bras at Le Mystere (one of which was featured on *The Oprah Winfrey Show* in 2003), Iris decided to open a shop—where she's become something of a local celebrity for her no-nonsense approach to fitting customers with the measurements they need. "She's like a firm but loving Auntie," said one frequent client.

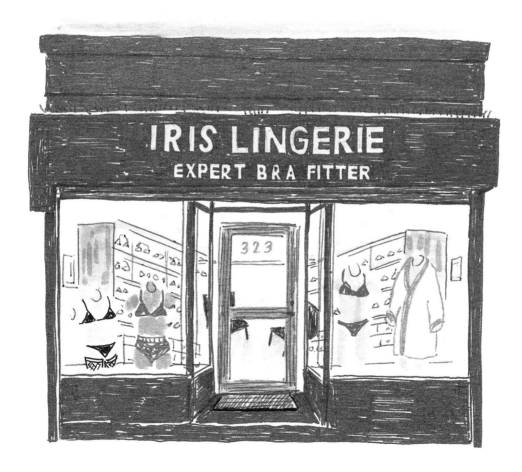

Cafe Erzulie

———

"Erzulie is the Haitian Voodoo spirit of love, beauty, and dance," relate the owners of this multifaceted spot on their website, and they take great care to appropriately honor its namesake. The space's floors are pink and blue, Erzulie's favorite colors. To celebrate the deity's love of baked goods, the business offers sticky buns as part of its menu. By day it sells flowers (another one of Erzulie's most liked things) and coffee. But by night it transforms into a cocktail bar and club that has become a hot spot with the Black queer community. It also hosts a famed free weekly jazz night that was covered in a 2022 *New York Times* write-up. "It's really not about the money on Jazz Night," co-owner Mark Luxama said in the article. "It's more about creating community and . . . space for the musicians to do their thing."

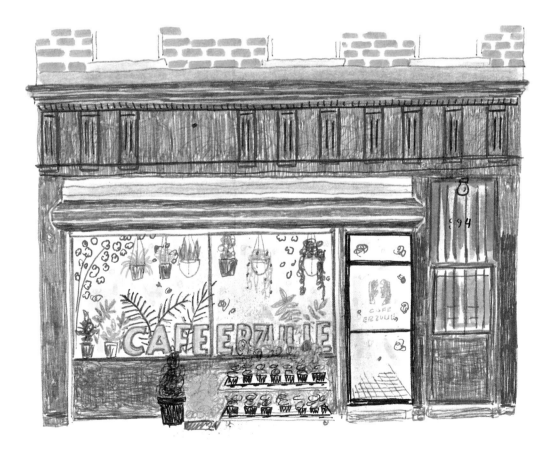

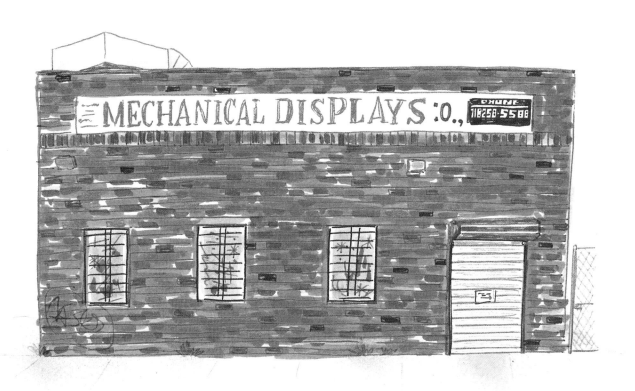

Mechanical Displays

———

Lou Nasti, who runs Mechanical Displays, is known as the Geppetto of Brooklyn—and he looks the part, too, thanks to his affable demeanor and white handlebar mustache. He got his start in mechanics as a teenager building robots. The *New York Times* even wrote up the young Lou's work in 1965, after he built a six-foot-tall light-up robot named Mr. Obos. Though M.I.T. offered Lou a scholarship, he decided to simply get to work instead. Since 1969 he's been busily making mechanical figures and toys for customers the world over.

Lou's busiest time of year is Christmas, when he's hired to install displays at stores, malls, and homes. He's largely responsible for the tourist attraction that has firmly taken root in Dyker Heights each holiday season, when the area is awash in life-size Santas, snow people, and a dizzying number of twinkling lights.

In 2017 Lou had to get seven men to help him deliver a 350-pound Santa head to one of the neighborhood's homes.

Though Christmas is king for Lou's business, he's hired to work on any number of projects that allow his imagination to run wild. (The actual king of Morocco reportedly recruited him to help decorate for a rager of a party.) Someone once asked him to turn an Indiana car wash into a jungle; as customers slowly inched through the wash, mechanical elephants rinsed off their vehicles with their trunks.

1985 Coney Island Ave.
Midwood

Argo

Favorites at this beloved family-owned Georgian restaurant include the *khachapuri* (cheese bread), *khinkali* (dumplings), and *pkhali*, a dish made with minced vegetables, ground walnuts, and herbs.

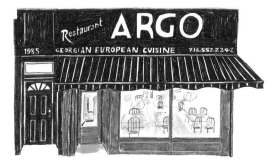

481 Myrtle Ave.
Clinton Hill

John's Donut & Coffee Shop

Much more than a donut shop, this greasy-spoon diner is the "best hangover breakfast spot" in the city, according to one online reviewer.

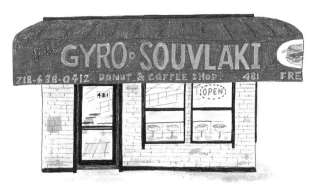

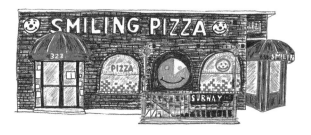

323 7th Ave.
Park Slope

Smiling Pizza

Smiling Pizza features an iconic red awning, plastic benches, and walls adorned with old-school posters of Sicily—and it's been this way since the 1980s. It's no-frills slices here, which is "exactly what a NYC pizza joint should be," said one regular.

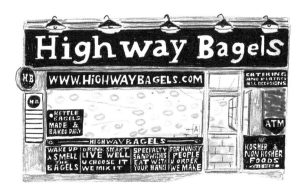

1923 Kings Hwy.
Midwood

Highway Bagels

Opened in 1951, this is one of the oldest still-operating bagel shops in Brooklyn. Current owners Luigi Curto and Alberto Pernicone have stayed true to Highway's tradition of producing authentic New York–style kettle bagels, dropping each ring of dough into a boiling pot of water to create a distinctive crisp outer shell.

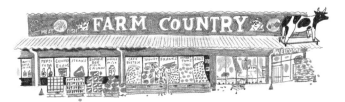

2205 Linden Blvd.
East New York

Farm Country of
East New York

—

Specializing in Caribbean food, this neighborhood grocery store is the type of place to phone up regulars when they have fresh crab in stock.

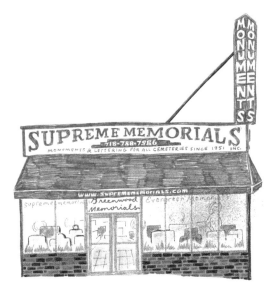

610 4th Ave.
South Slope

Supreme Memorials

—

This tombstone-making outfit—whose motto is "Every Life Is Unique and Beautiful . . . Your Memorial Should Be, Too"—is a fourth-generation, family-run business that has been creating marble and granite monuments and mausoleums since 1951.

238 Court St.
Cobble Hill

Sam's Restaurant

—

The Migliaccio family has owned the building that houses Sam's Restaurant since the 1930s, meaning the gentrification of the surrounding neighborhood hasn't forced this old-school red-sauce and pizza joint to veer from its classic and beloved pies.

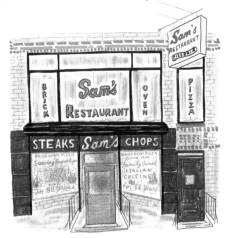

9602 Church Ave.
East Flatbush

Sandra's Luxury Studio

—

Owned by Guyanese stylist Ceshanna Andrew Anthony, this spot specializes in wigs made with human hair. Ceshanna has even offered a multiday course to teach you how to apply and style them.

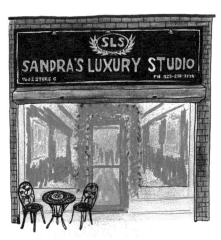

String Thing Studio

———

This is "not your grandmother's yarn shop," according to String Thing Studio's website; "it's more your auntie, cousin, best girlfriends' yarn shop!" In fact, it's actually Felicia Eve's store, who is like "your cool, fun aunt you kiki with over a bottle of wine," according to online publication Black-Owned Brooklyn.

Felicia opened the business in 2017 to meet the crochet and knitting needs of Park Slope residents but also to provide a sense of community for fellow craft lovers. She hosts a knitting and crochet party in the backyard each Friday, plus offers classes for beginners, intermediates, and kids. Every year she even organizes a field trip for regulars to visit yarn shops in the Hudson Valley.

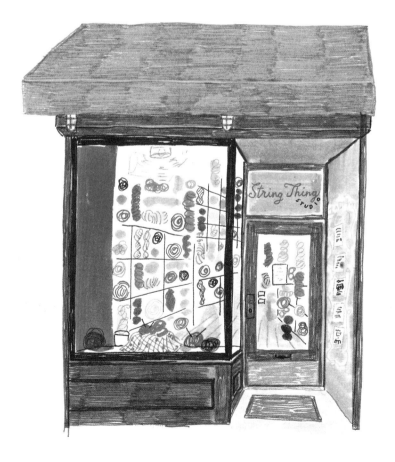

Diner

———

When Andrew Tarlow first opened Diner (in an actual train dining car, no less, under the Williamsburg Bridge) on New Year's Eve in 1998, it was one of only a handful of local restaurants. Today you can't throw a rock in the area without breaking the window of an up-and-coming eatery that claims to do things "a bit differently."

Andrew is often credited (or blamed, depending on who you talk to) for putting Williamsburg on the map as a booming dining destination. Despite the competition, Diner remains a beloved institution, retaining its devoted fan base thanks to a seasonal menu, with food options that change almost daily—save, of course, for the spot's famous burger, which is always available.

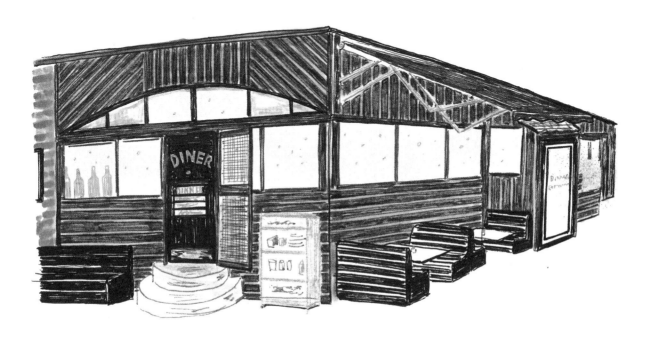

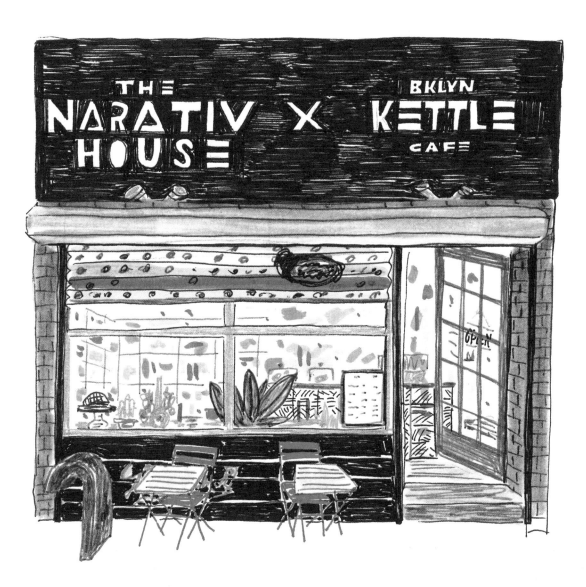

385 Tompkins Ave.
Bedford-Stuyvesant

The Narativ House

When Farai Simoyi (who rose to fame on the Netflix reality competition show *Next in Fashion* in 2020) took trips back to Zimbabwe, where she was born and raised, her neighbors in Brooklyn often envied the items she'd return with, including clothes, fabrics, and other artisanal items. In 2017 she decided to open the Narativ House, a concept store in Bed-Stuy, to help African artists be "seen, valued, and heard," according to its website.

In 2021, during the height of the coronavirus pandemic, Farai merged the Narativ House with Brooklyn Kettle, a coffee shop owned and operated by her husband, Ayo Agbede. Though intended simply to keep both businesses afloat, the union created a beloved neighborhood spot where people can eat, drink, shop, and socialize.

Contributors to the Narativ House, known as "narrators," are designers and artisans who have a passion for sustainability and a commitment to traditional craftsmanship.

Through their creations, these artists are on a mission to share their stories with the Brooklyn community. The group includes people like Laolu Senbanjo, who applies his Nigerian-inspired artwork on luggage, masks, human skin—and "just about any and everything" he can get his hands on, according to his bio on Narativ's site. Also involved is the Burundi-based collective Margaux Wong, which repurposes materials like discarded cow horns and brass to create handmade jewelry using time-honored techniques.

7205 18th Ave.
Bensonhurst

Queen Ann Ravioli

Italian immigrant Alfredo Ferrara opened this spot in 1972, and today it's owned and operated by his grandchildren. The fresh pasta–making institution is particularly known for what one online reviewer referred to as "billowy clouds of joyful ravioli."

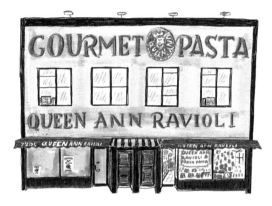

484 Union Ave.
Williamsburg

Union Pool

"We are sorry to report that, despite the name, Union Pool does not offer swimming or billiards," this spot says on its website. The bar, which opened in 2000, took its name from the site's former tenant, a swimming pool–supply store.

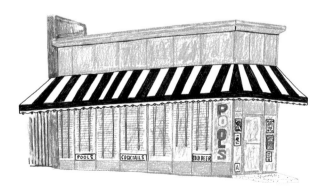

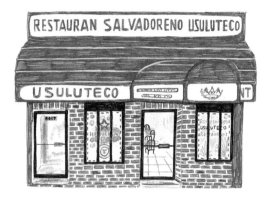

4017 5th Ave.
Sunset Park

Usuluteco

Sunset Park restaurant Usuluteco—painted blue and white to represent El Salvador's flag—cooks up the country's national favorites, including *pupusas* (flatbread) and churrasco Salvadoreño. There's a second location nearby.

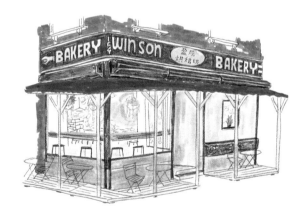

164 Graham Ave.
East Williamsburg

Win Son Bakery

Favorites at this Taiwanese American bakery include the bacon, egg, and cheese served on a scallion pancake, as well as turnip cakes and rice rolls. Just across the intersection is their full-service restaurant, which is also called Win Son.

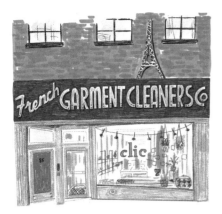

85 Lafayette Ave.
Fort Greene

Clic

———

Christiane Celle opened this bookstore and gallery in 2008—in the former location of a French laundromat, per the iconic signage outside—and has since expanded into home goods and apparel. She operates several additional shops, including in East Hampton and in St. Barths, the original location.

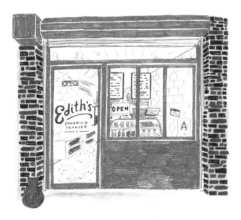

495 Lorimer St.
Williamsburg

Edith's Sandwich Counter

———

A modern Jewish sandwich counter, Edith's started as a pandemic-era pop-up at Paulie Gee's Slice Shop (p. 30). It serves bagels made from scratch, hot sandwiches (like the BEC&L—bacon, egg, and cheese on a latke), and tahini cold-brew slushies.

1127 Nostrand Ave.
Prospect Lefferts Gardens

Labay Market

———

MacDonald Romain, better known to his customers as "Big Mac," packs this market with Caribbean imports like sea moss, soursop, breadfruit, callaloo, tamarind pickle, and jackfruit. He sources much of what he sells directly from his family's sixty-acre estate in Grenada.

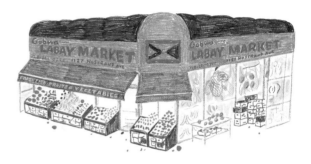

616 Grand St.
Williamsburg

Superior Elevation Records

———

A vinyl collector's dream, this shop boasts an impressive selection of records spanning soul, funk, R&B, hip-hop, reggae, jazz, and more. Dust off your own collection for a chance to sell here—Superior Elevation buys used records daily.

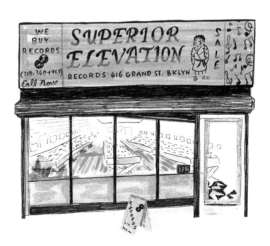

Brooklyn Inn

———

The Brooklyn Inn, which is among the oldest bars in the borough, first opened in 1885 at this location on the corner of Bergen and Hoyt Streets. A group of German architects and contractors designed it in the saloon style popular in the United States at the time, with high ceilings, detailed woodwork, stained glass, and mirrored walls. One of the contractors carved a symbol under the bar that represents the Germanic god Odin, who represents capability, inspiration, and (fittingly) intoxication. The space's numerous owners have largely kept these original details intact over the years but have made a few welcome additions, including an old-school jukebox.

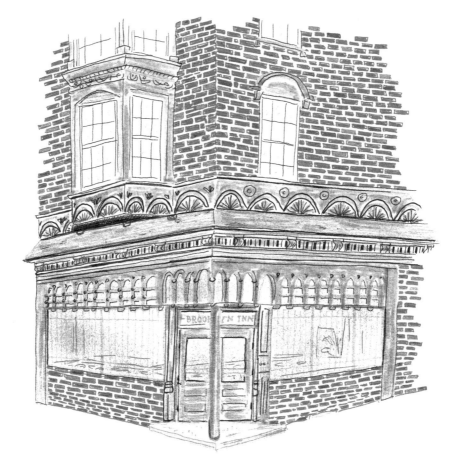

Carolina Country Store

———

In 1973 George Lee established this specialty store to help introduce Southern food to the Brooklyn community. As it has since it first opened its doors, the shop procures most of its goods directly from Southern farmers and then trucks them up directly to the storefront on Atlantic Avenue. Carolinian staples like sage sausage, pork cracklings, and liver pudding continue to be among the business's most popular offerings. A can in the window claims to sell "potted possum," which is probably a joke.

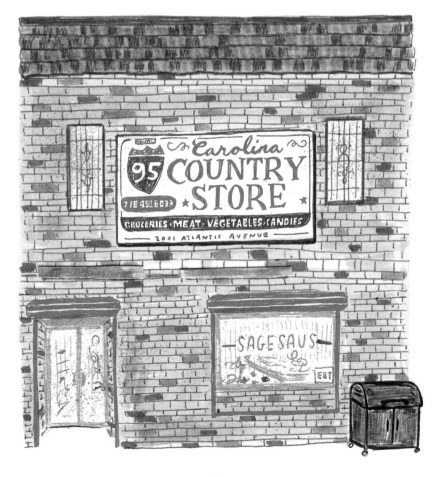

Life Wellness Center

———

Khadija Tudor and Ade Collman launched Life Wellness Center in 2015 to "spark awareness about the importance of health, self-love, and how we care for our bodies," according to their website. The couple set out to create an environment that is more than a massage and acupuncture clinic, a place that feels like stopping by "that auntie's house that is really dope," Khadija told Mademenoire.com. An aroma of eucalyptus, a jungle's worth of plants and flowers, and music entice guests inside the studio, which functions as an apothecary, too, with a variety of teas, tonics, and elixirs on offer.

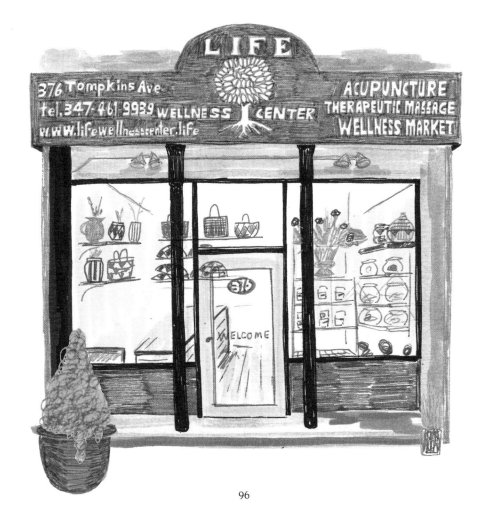

Montero Bar & Grill

——

This dive bar, which has been operating in the Brooklyn Heights neighborhood since 1939, is one that "even grandmothers would like," according to a write-up in the *New Yorker*. It's the type of place that values genuine conversation over loud music—that is, unless it's karaoke night. Then, all bets are off.

Montero used to be a longshoreman's hot spot, opening at 8:30 a.m. to accommodate thirsty sailors. Nowadays the bar continues to honor its nautical past with decor that includes model ships, buoys, and newspaper cutouts.

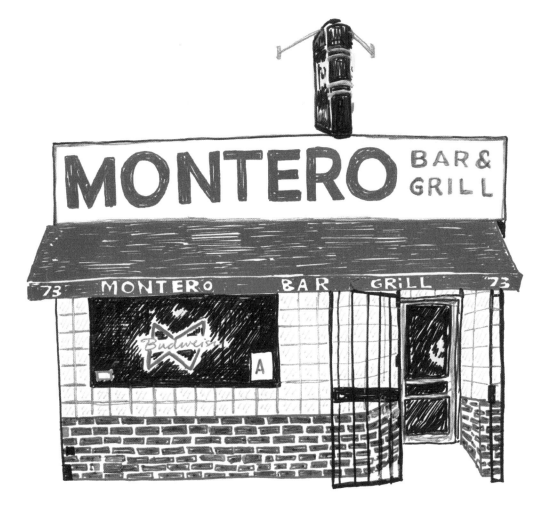

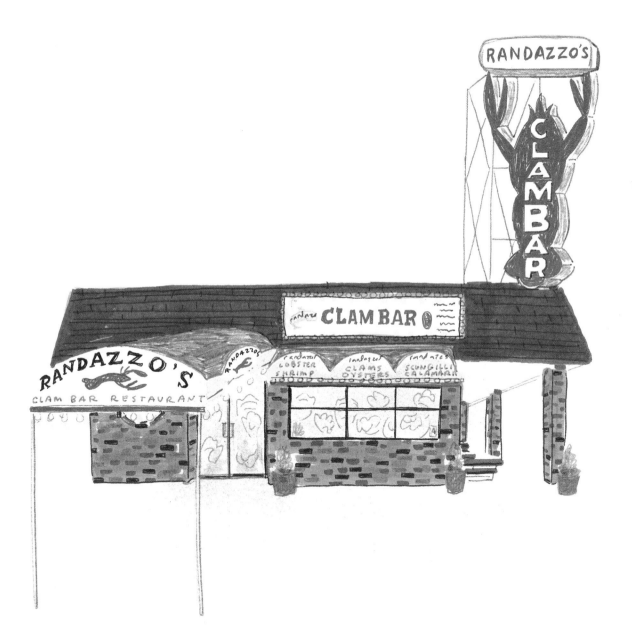

Randazzo's Clam Bar

———

The Randazzo family has been in the seafood business for more than a century.

Sam Randazzo opened their first market on the Lower East Side of Manhattan around 1920 but relocated to Sheepshead Bay a decade later, which at the time was a deserted area consisting mostly of farmland, dirt roads, and fishing boats.

In 1959 Sam's daughter Elena opened a bar where she began cooking her great-grandmother's recipe for fried calamari (which they call *Gal-a-Mah*), made with spicy tomato sauce. Decades later, a *New York Times* food critic would say the sauce "tastes as if a chemical analysis would reveal the blueprint for every great dish in every red-sauce joint in the country." Apparently, Elena's contemporaries agreed—her Gal-a-Mah was so popular that she eventually broadened the menu to offer shrimp, mussels, scungilli, and raw and baked clams. Thus, Randazzo's Clam Bar was born.

Throughout the 1980s and '90s, the family expanded the business even further, venturing into a couple of (since closed) Italian eateries and an additional fish market. Randazzo's has operated at this Emmons Avenue location since 1986, instantly recognizable thanks to the giant lobster-shaped sign hoisted over the building that bears the restaurant's name. At the time it was one of many clam joints in Sheepshead Bay. Today, it's the last standing in the neighborhood.

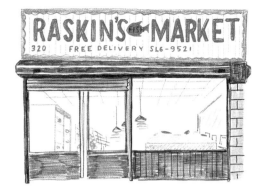

320 Kingston Ave.
Crown Heights

Raskin's Fish Market

—

Berel Raskin opened this family-owned kosher fishmonger with the motto "askin' for Raskin" in 1961. It offers fresh fish, canned items like gefilte fish, smoked fish, fish marinades, and more.

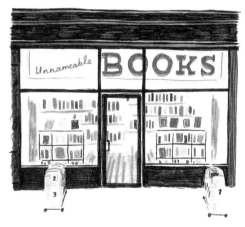

615 Vanderbilt Ave.
Prospect Heights

Unnameable Books

—

Cartoonist Adrian Tomine drew this independent bookstore (which he used to live next to) for the cover of a 2008 issue of the *New Yorker*, as part of a profile detailing how the shop had survived the wave of big-box bookstores and the emergence of online sales outlets.

1656 Pitkin Ave.
Brownsville

Pitkin Wonderful Shoes

—

This store specializes in "Ladies & Kids Fashion Shoes," as they relate on their green awning—and was the go-to spot for at least one online reviewer to buy "two pairs of shoes for prom."

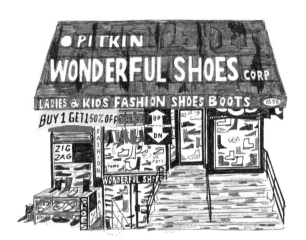

170 Montrose Ave.
East Williamsburg

Yun Hai Taiwanese Pantry

—

This grocery is the place to go for all your Taiwanese needs, including imported dried fruit, hot and soy sauces, and even the trademark green-and-red mailboxes prevalent throughout the country.

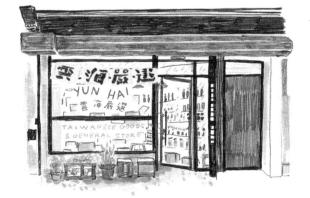

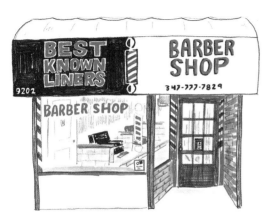

9202 Ave. M
Canarsie

Best Known Liners Barbershop

———

At Best Known Liners, "You don't ever have to worry about leaving the barbershop with your hairline behind your ears," according to one review—that is, unless you want a sick design etched into your fade, in which case owner Rodney Ben will be happy to oblige.

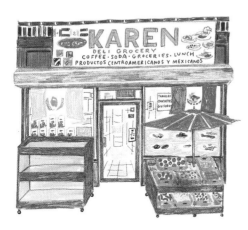

6116 5th Ave.
Sunset Park

Karen Deli Grocery

———

Busy locals know to duck into this store, which is stocked with Guatemalan, Mexican, and other Central American staples, for a quick bite. *Pepián*, a stew with pumpkin seeds, is a crowd-pleaser. Head to the back for a peak at the massive mural of Guatemala.

2201 Ave. X
Sheepshead Bay

Lucia Pizza of Avenue X

———

Owner and head chef Salvatore Carlino opened this pizzeria in 2022, but his family has been in the pie-slinging business since 1974. Salvatore's menu goes beyond offerings found at most pizzerias. The Caramelle Piccanti, for example, features pepperoni, hot cherry peppers, and hot honey.

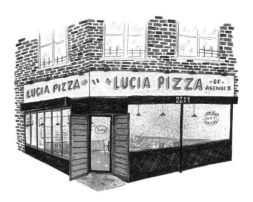

343 Tompkins Ave.
Bedford-Stuyvesant

Sincerely, Tommy

———

Kai Avent-deLeon, the owner of this Bed-Stuy boutique, which is equal parts clothing and concept store and coffee shop, also founded Building Black Bed-Stuy, a nonprofit dedicated to providing financial relief for the area's Black-owned businesses and organizations.

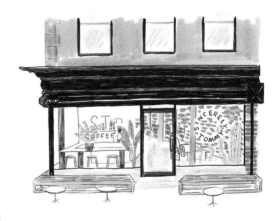

P.I.T.

This store, the name of which stands for "Property Is Theft," offers much more than records. As its website explains, the founders are on a mission to "provide uncommodified community space" to Williamsburg residents via affordable music lessons, facilities for artists, and a free venue for performances, readings, and activist gatherings. Visit on any given day and you may walk into a meeting of unionized workers from Rutgers University, author Chad Pearson reading from his book *Capital's Terrorists*, or a conversation on "degrowth" in New York City. Yes, you can buy music here too.

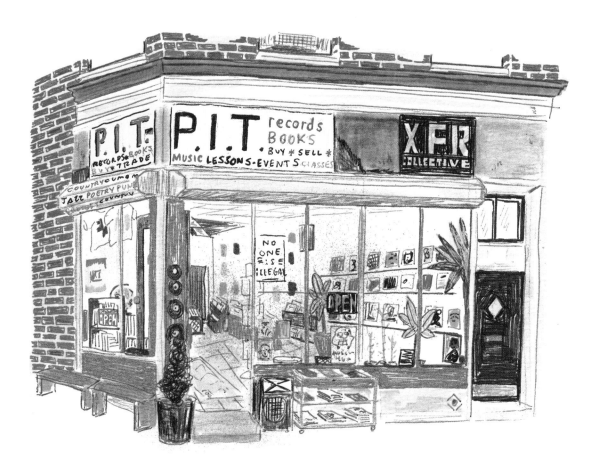

Juliana's Pizza

Pasquale "Patsy" Grimaldi and his wife, Carol, founded Grimaldi's Pizzeria at its iconic storefront on Old Fulton Street near the Brooklyn Bridge in 1990. A couple of decades later, the pair retired and sold off their shares in the company. But Patsy and Carol couldn't stay away from the business for long. In 2012, at the age of eighty-three and seventy-four, respectively, the duo partnered with a friend to open Juliana's as a competing thin-crust pizza shop—complete with the first hand-built, coal-fired oven commissioned in New York City in over fifty years. The same year Juliana's opened, the spot won Best Pizzeria via an audience vote on TripAdvisor.

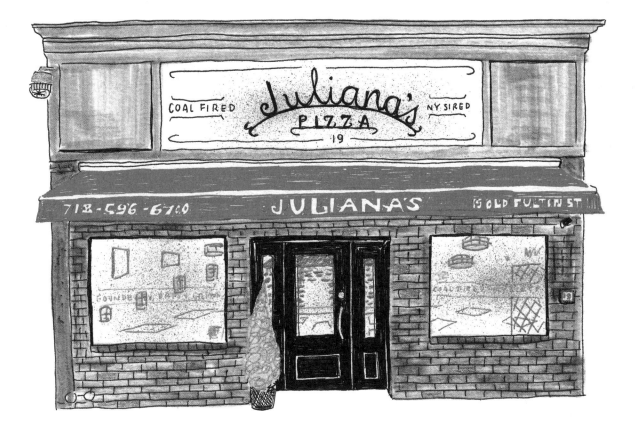

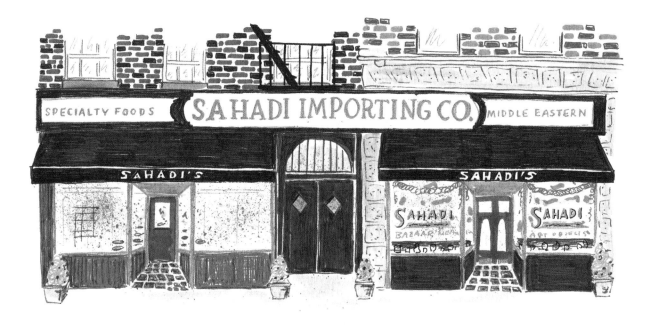

Sahadi's

———

Originally opened in 1895 by a Lebanese family in an area of Lower Manhattan formerly known as Little Syria, this Middle Eastern grocery store is routinely mentioned among the best in the world. In 1899 Sahadi's received its first of many mentions in the *New York Times*, which wrote that the spot was "a wonderful shop" with "swords and lamps, glass bracelets of many colors, Oriental embroideries, water pipes (hubble bubbles) and their 'fixings.'" In 1948 the construction of the Brooklyn–Battery Tunnel forced the family to move the business to its current home in Brooklyn Heights.

Operated today by the fourth generation of Sahadis, the shop continues its more than century-old tradition of selling in bulk, offering over two hundred containers heaping with grains, roasted nuts, dried fruits, coffee beans, and more. Its fridges are stocked with specialty cheeses, smoked fish, and pâtés. In 2017 the James Beard Foundation gave the store an America's Classic award, which recognizes shops reflecting "the character of their communities." In 2019 Sahadi's expanded to a second location at Industry City. And in fall 2023 the store announced the opening of a new location inside Chelsea's Market57, the James Beard food hall—returning the shop to its Manhattan roots after nearly 130 years.

Some regulars who are transplants from Middle Eastern countries come here as much for the nostalgia it stirs in them as for the food offerings.

"I go to Sahadi's for *manaqish* (bread baked with *za'atar*), and to get a whiff of my childhood," a professor of Near Eastern studies told the *New York Times*. Another said, "I go to Sahadi's at least once a month to recharge my emotional batteries."

1359 Coney Island Ave.
Midwood

Essen New York Deli

———

This Jewish deli is a throwback to an earlier era in New York. Its staff cures and smokes all their meats by hand—and serves the best pastrami sandwich in the city, according to the website the Infatuation.

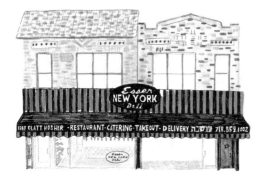

145 Atlantic Ave.
Brooklyn Heights

Luzzo's BK

———

Since opening in 2013, this pizzeria has been making its pies in 120-year-old coal ovens—some of the few remaining in the entire city. There's a Luzzo's in Los Angeles' Studio City neighborhood too.

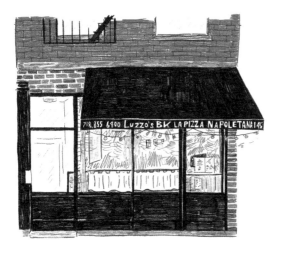

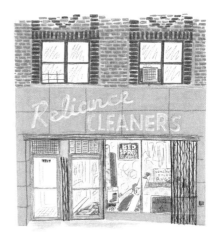

7717 5th Ave.
Bay Ridge

Reliance Cleaners

———

This dry cleaner had been a beloved staple in the Bay Ridge community for half a century before closing its doors in June 2023. For once, the cause wasn't the result of rising rents or gentrification—owner Vicky was simply ready to retire.

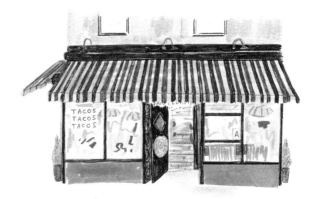

320 Van Brunt St.
Red Hook

San Pedro Inn

———

Open since 2019, this bar doubles as a Mexican restaurant, with food that regulars say defies its classification as a "dive." They even make their own fermented hot sauce and tortillas.

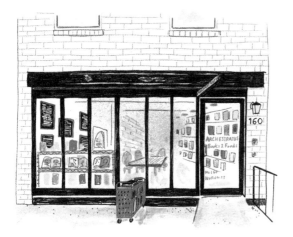

164 Huron St.
Greenpoint

Archestratus Books + Foods

—

Paige Lipari first opened this cookbook-focused Greenpoint store in 2016. In subsequent years Archestratus has expanded to include an Italian grocery and food and drink offerings.

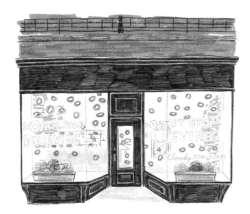

14 Columbia Pl.
Brooklyn Heights

Cloudy Donut Co.

—

Cloudy Donut Co., which has a second location in Baltimore, is completely vegan. It offers customers a choice between more than forty flavors, including options like Sexual Chocolate, Cookie Monster, and Orange Creamsicle.

98 Meserole Ave.
Greenpoint

Good Room

—

Since 2014 this nightlife venue—which *DJ Mag* awarded the title of "best small club in North America" in 2022—regularly hosts parties with DJ legends such as Nicky Siano, Octo Octa, Four Tet, Honey Dijon, and the Carry Nation.

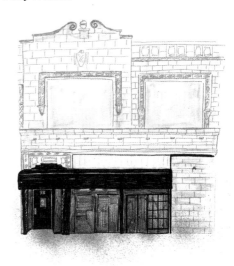

5204 8th Ave.
Sunset Park

Lucky Eight

—

Regulars say the tricks when ordering at this Michelin-recommended Cantonese restaurant are to eat family style, be a bit adventurous, and make sure to get plenty of barbecued meats.

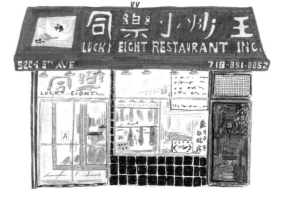

BierWax

———

Husband-and-wife duo Chris and Yahaira Maestro opened this shop in 2017 to combine their two great loves into one: vinyl records and craft beer. Today the couple boasts around five thousand records on offer at the store—and an equally impressive number of locally sourced beers on tap.

A longtime DJ and vinyl aficionado, thousands of records from Chris's personal collection line the wall behind the bar—a concept patterned after Japanese *jazu kissa*, or jazz cafés, where music enthusiasts can enjoy a drink or two while listening to samples from the owners' record collections. "I can curate amazing beer and sounds," Chris said in an interview with the website VinePair after a trip to Japan; "I need to bring this to New York." In 2022 BierWax opened a second location in Ridgewood, Queens.

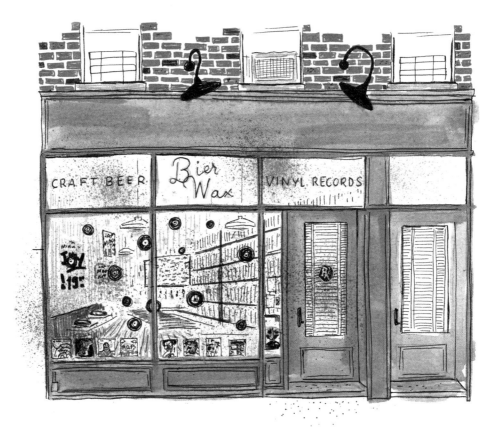

Emma's Torch

Equal parts café and social enterprise, this nonprofit hires and trains refugees, asylees, and survivors of trafficking to pursue careers in the restaurant industry. During the ten-week apprenticeship program, participants learn to sharpen knives, prepare food, write resumes, and improve their English—both on the job at the café and in a classroom setting. Nearly 90 percent of trainees go on to find full-time culinary work. The café is named after refugee advocate Emma Lazarus, whose poem "The New Colossus" ("Give me your tired, your poor, your huddled masses") has long welcomed new immigrants to the United States at the base of the Statue of Liberty.

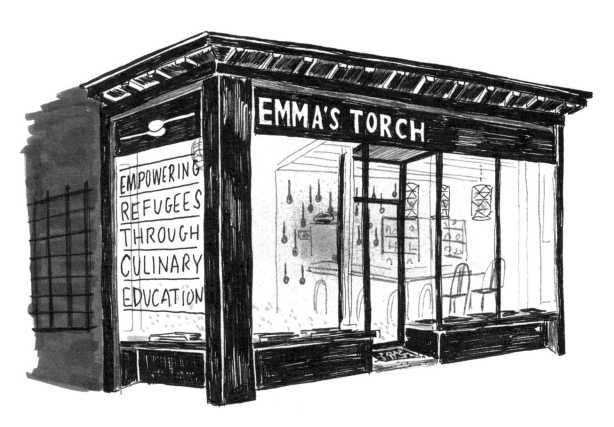

Sunny's Bar

This bar has been owned and operated by the same family since 1890; over the years it's been a restaurant and a longshoreman's watering hole. In its latest incarnation, Sunny's is a popular, casual drinking establishment with weekly country and bluegrass jam sessions.

Antonio Balzano, better known as Sunny, inherited the bar in the 1980s and somewhat reluctantly operated the space until his death in 2016. To pursue his other passions, like acting and painting, Sunny initially opened the bar just one day a week—which had the unintentional consequence of making it an underground sensation. As the neighborhood gentrified, Sunny eventually extended to a six-day week, succumbing to his destiny as a beloved neighborhood barkeep known for welcoming anyone. "This isn't my bar any more than it's anyone else's bar," he said once in an interview. "It belongs to each of you. . . . It's our bar, aye?"

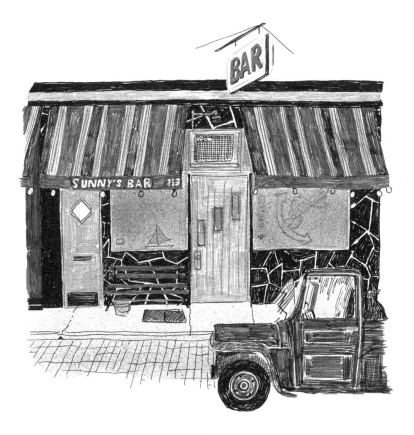

Defonte's Sandwich Shop

Open since 1922, this deli has stayed in business for over a century thanks in part to its extensive menu of sandwiches made the old-fashioned way: stuffed to the gills on a hero. "Defonte's doesn't do its take on a classic," the Infatuation wrote in a review; "Defonte's is the classic." Favorites include the Golden Boy, a combo of chicken cutlet, fresh mozzarella, prosciutto, and creamy vodka sauce, and the Nicky Special, a sandwich stacked with ham, capocollo, salami, fried eggplant, provolone cheese, and more.

To be clear, Defonte's is not a restaurant. It's a true deli, with no waiters or places to sit. In old-school New York fashion, customers order sandwiches made with homemade ingredients at the counter, take them to go, and get on with their days.

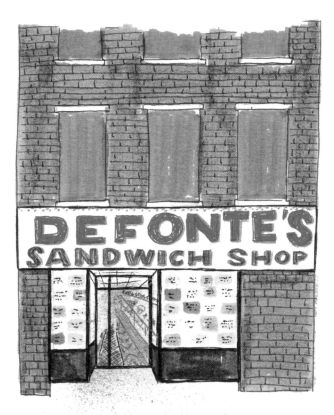

372 5th Ave.
Park Slope

The Brooklyn Superhero Supply Co.

———

Much like Clark Kent and Superman, this store has dueling personalities. At first glance, it may look like the company does nothing more than sell superhero-related apparel, gifts, and books. Dig a bit deeper and you'll discover a nonprofit, called 826NYC, hidden behind a secret door and dedicated to improving the creative writing skills of young people.

Classes on offer include playwriting, sci-fi, and even a course focused entirely on the world of Dungeons & Dragons fan fiction.

This scholastic emporium was the brainchild of educator Nínive Calegari and famed author Dave Eggers, who opened their first spot at 826 Valencia Street in San Francisco in 2002. Though they had intended to run the nonprofit out of the storefront, it was zoned for retail—so the duo opened the Pirate Supply Store, mostly out of necessity. But they soon came to see the value in pairing unusual storefronts with their charitable enterprises. They help act as "imaginative portals," according to their website, drawing in curious passersby.

As Nínive and Dave have expanded the philanthropic 826 idea to cities across the country, each has been paired with a whimsical storefront. The Echo Park location in Los Angeles doubles as the Time Travel Mart, for instance, while the Boston branch is known as the Bigfoot Research Institute.

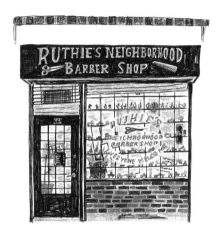

66A St. Marks Ave.
Park Slope

Ruthie's Neighborhood Barber Shop

Ruthie Boirie has been providing the Park Slope community with cuts, shaves, and fades since 1995. A carpenter by trade, she also uses the storefront as her workshop.

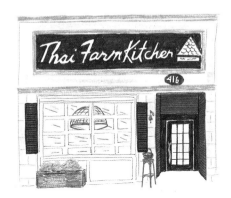

416 Church Ave.
Kensington

Thai Farm Kitchen

Husband-and-wife duo Jess and Elizabeth Calvo opened this Thai restaurant in 2018 with a menu the *New York Times* described as filled with "quiet intent and zeal for detail." Coconut delight (or *wun maprao onn*) is a crowd-pleaser—but Elizabeth, who works as the chef, won't make the dessert unless she's stocked with the "right young coconut."

176 Atlantic Ave.
Cobble Hill

Yemen Cafe & Restaurant

This Yemeni restaurant, which opened in 1986, offers complimentary flatbread, iceberg salad, and *marag* (spicy mutton soup)—but be sure to leave room for the lamb, which gets slow-roasted over the course of five hours. Another outpost is in Bay Ridge.

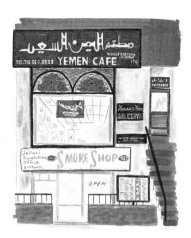

6 Porter Ave.
Bushwick

YourHairsBestFriend

Regulars of this salon would agree that owner Chereen Monet really is the BFF to their bouffants. She has developed a loyal fan base thanks, in part, to her specialty: concocting custom colors to bring her clients' hair to the next level.

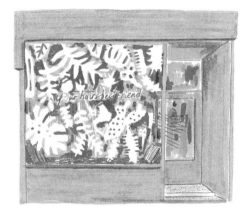

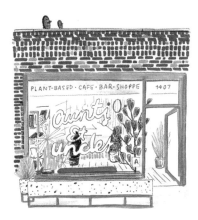

1407 Nostrand Ave.
Flatbush

Aunts et Uncles

Nicole and Michael Nicholas opened this restaurant and retail space in 2020. They've quickly made a name for themselves on the booming vegan restaurant scene thanks to their inventive Caribbean-leaning menu, which includes a "beautifully folded, flaky" Haitian-style patty made with Beyond Beef, according to a review in the *New Yorker*.

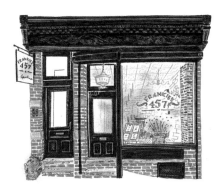

457 Court St.
Carroll Gardens

Frankies 457 Spuntino

Reflecting on his time as a food critic in his final piece for the *New York Times*, Sam Sifton wrote of this Italian restaurant, opened in 2004 by a pair of Franks (Castronovo and Falcinelli): "The best meal I had on the job? It was in the garden of Frankies 457 . . . on a summer evening."

1211 Myrtle Ave.
Bushwick

Happyfun Hideaway

Unlike some of its sleeker Bushwick neighbors, this tiki-themed queer bar keeps the drinks cheap and flowing, eliciting some online reviews like this one: "Sorry stole your pen but love this place. I don't remember what I did during Halloween."

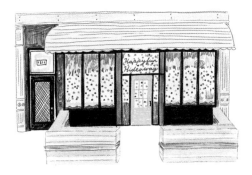

1196 Gravesend Neck Rd.
Sheepshead Bay

Russian Baths

This Russian bathhouse (or *banya*) sports three saunas, a steam room, a pool, a full bar, and a restaurant. The wet spa is a "geographic and cultural trip" for "jolly shirtless men," according to its website.

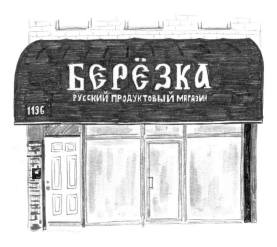

Farrell's Bar & Grill

———

Farrell's Bar & Grill first opened in Windsor Terrace in 1933, when the area "was Irish and Irish meant tough," according to a review in *New York* magazine. For the first few decades, women weren't allowed to order drinks themselves, relying instead on their male chaperones. In the 1970s actor Shirley MacLaine became the first female to break this glass ceiling when she walked into Farrell's and insisted on being served. Still, the bar didn't officially retire the policy until 1980. Whatever your gender, don't come here expecting to order a margarita or even tequila—this is a beer and shot of whiskey joint.

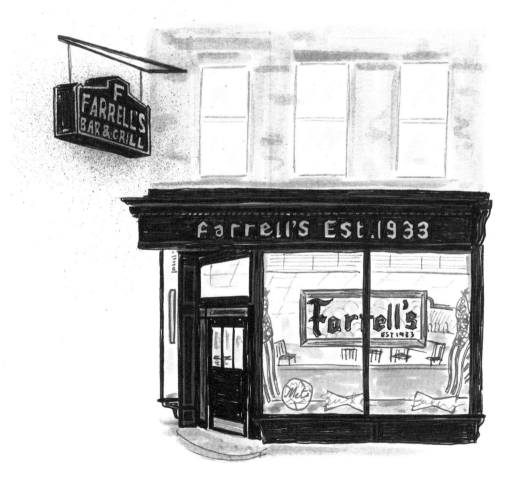

143 7th Ave.
Park Slope

Community Bookstore

———

Susan and John Scioli opened this spot in 1971, making it the oldest still-operating independent bookstore in all of Brooklyn. Its longevity is due in large part to Susan's ingenuity—when Barnes & Noble opened a store nearby in 1997, she developed a business plan to stay competitive, which included new inventory, a café, a backyard space, and a rewards program. The store has continued to thrive, and Susan even opened an offshoot in Windsor Terrace that specializes in used books.

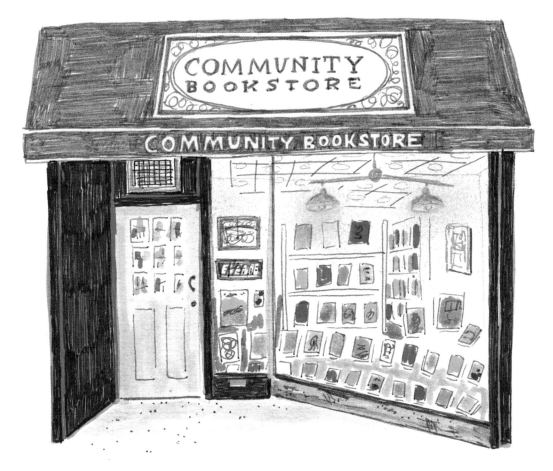

Broadway Pigeons & Pet Supplies

Brothers Joey and Michael Scott have long been pigeon lovers—it's an interest they picked up from their grandfather, who kept hundreds of birds at his home in Canarsie. They inherited the flock when he passed away and, after selling that property in the early 2000s, bought an entire building in Bushwick to house the birds on the roof. Soon after they opened a pet-supply store on Broadway, where Bushwick meets Bed-Stuy, to sell to fellow collectors, as pigeon-keeping was a pastime previously shared by many of their neighbors.

These days, pigeon enthusiasts are in decline thanks in large part to a gentrifying Brooklyn.

"Who has the time, who has the money, and who has the roof?" Joey replied when asked about this trend in a 2021 *New York Times* interview. Apparently, building owners in trendy neighborhoods may be quick to permit gardens and gazebos on their rooftops, but few even consider allowing aviaries. Modern bird flus have also made the hobby prohibitively expensive for many; the Scotts must routinely vaccinate their flock against the latest avian-borne illnesses.

As pigeons have dwindled in popularity over the years, the Scotts have pivoted to offering more traditional pet products, such as supplies for cat and dog owners. Still, they do sell some pigeons—many customers today, however, don't tend to share their love of the homing birds. One purchased pigeons to help train his dog to hunt, while another bought several to assist her in fulfilling a religious ceremony, the brothers told the *Times*.

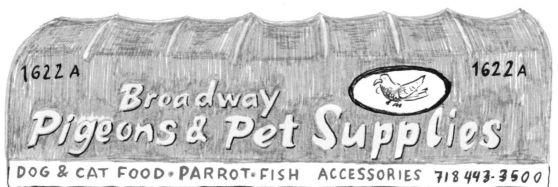

1622 A

1622 A

Broadway
Pigeons & Pet Supplies

DOG & CAT FOOD • PARROT • FISH ACCESSORIES 718 443-3500

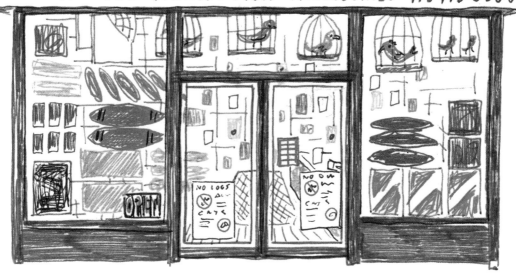

Singers

———

In an era that has seen bars catering to the LGBTQ community dwindle across the country, Singers is one of a growing number of drinking establishments in Brooklyn proving to be the exception. "We wanted to create a queer space, but really didn't want it to be a gay bar," Mike Guisinger, who opened the bar with Brooke Peshke in 2022, said in an interview with online magazine Them. Singers's success is thanks, in part, to its popular programming. There are weekly karaoke and trivia nights, along with special events like a "twinks-versus-dolls wrestling contest in a lube-filled kiddie pool." Other happenings include piglet tea parties, when patrons are welcome to pet miniature pigs in the backyard, and screenings of movies like Bruce LaBruce's pornographic comedy *The Raspberry Reich*.

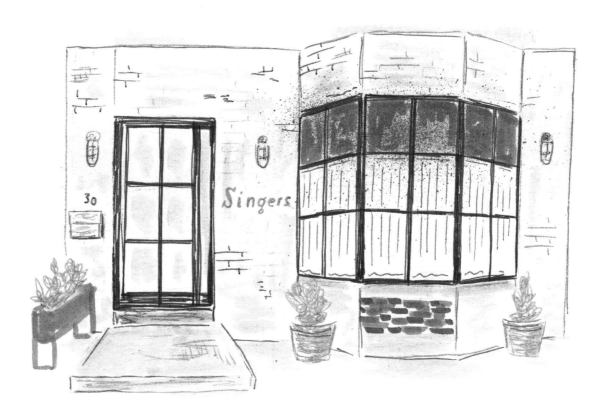

New York Transit Museum

Located in a former subway station decommissioned in 1946, the New York Transit Museum boasts vintage subway cars and other historical artifacts from the city's transit history, making it a common movie and television set for period pieces. The museum was made possible largely because of Don Harold, a Transit Authority employee who made it his mission to save classic train cars from the junkyard, sometimes by any means necessary. While on the job, he paid close attention to cars scheduled to be retired, secretly changing their numbers so they couldn't be identified. Thanks to this subterfuge, the *New York Times* dubbed him the "Sneaky Subway Preservationist" in his obituary. Many of Don's antique trains eventually found their way to a permanent home at the museum.

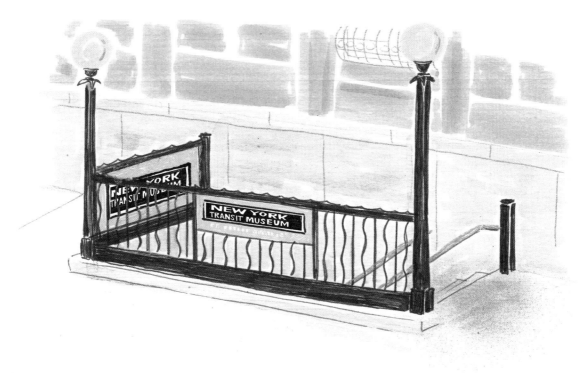

San Toy Laundry

The storefront at 101 Seventh Avenue has been home to a Chinese-owned laundromat for more than a century. Current proprietors Judy and Michael Huang have been keeping the tradition alive since 1983 when they bought the shop from its previous owner; monthly rent was just $325 at the time.

San Toy's shelves are lined with unclaimed clothing items, but the Huangs refuse to throw anything away. "Maybe someday they'll come back," Judy told the *New York Times* in an interview. Regulars are each given a permanent number—and the couple knows most of their customers' numbers by heart, if not their names. (Number eighty-nine belongs to US Senator Chuck Schumer.)

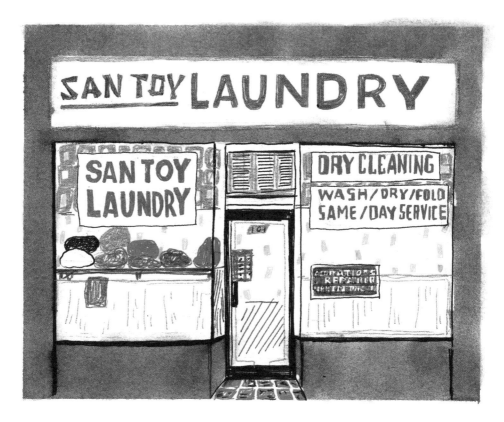

Gage & Tollner

Charles M. Gage opened this restaurant in 1879, and it took on its current name in 1884 after one of his regulars, Eugene Tollner, joined the business. It operated continuously until 2004, when the space was taken over by a rotating cast of fast-food chains like TGI Fridays and Arby's.

In 2017 restaurateurs Ben Schneider, St. John Frizell, and Sohui Kim discovered the location and began making plans to restore it to its former glory, which they eventually did in 2021. Gage & Tollner's impressive chandeliers may no longer be powered by gas, as they were up until 2004, but the electric versions "seem to glow more warmly than they did in the gaslight days," according to a *New York Times* review.

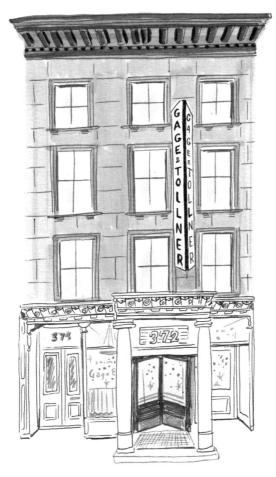

St. Ann's Warehouse

———

This performing-arts venue first opened in 1980 as a home for classical music at St. Ann's and the Holy Trinity Church in Brooklyn Heights. In 2001 it relocated to an old spice-milling factory and proceeded to welcome the likes of David Bowie, Lou Reed, Aimee Mann, and Rufus Wainwright to its stage. In 2015 the venue moved into a former tobacco-storage facility that can house seven hundred people, located alongside Brooklyn Bridge Park.

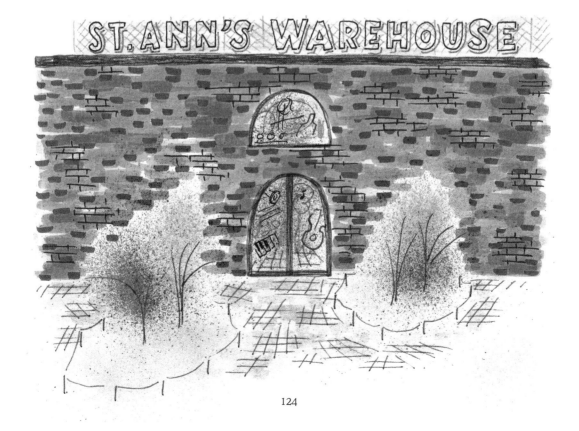

Tortilleria Mexicana Los Hermanos

———

The smell of freshly cooked tortillas should be enough to make you stop while walking by this factory—and if it isn't, you may not deserve to visit the hidden taco stand inside. As *New York* magazine wrote in a review, "The heavenly maize flats come off the line warm and chewy." Toppings for the tortillas include vegetarian options such as beans, sliced avocado, and grated white cheese, but regulars say the meats—specifically the spiced beef, carnitas, and chorizo—are the reason to eat your meal inside this industrial warehouse.

Diners enjoy their tacos, cooked from a street cart inside the shop, while staff behind a plexiglass partition bag stacks of tortillas. If you eat on the later side, you may even be treated to disco lights and Latin beats once workers have finished their shifts.

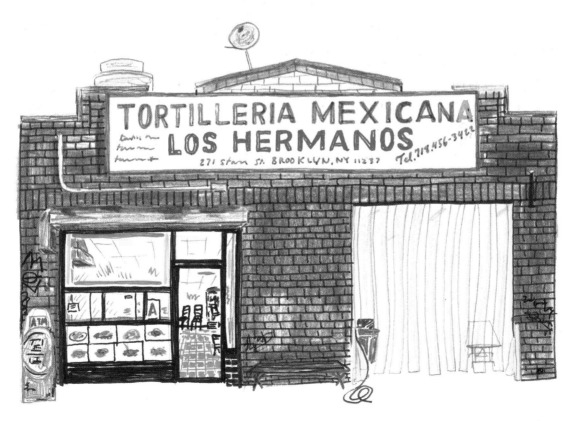

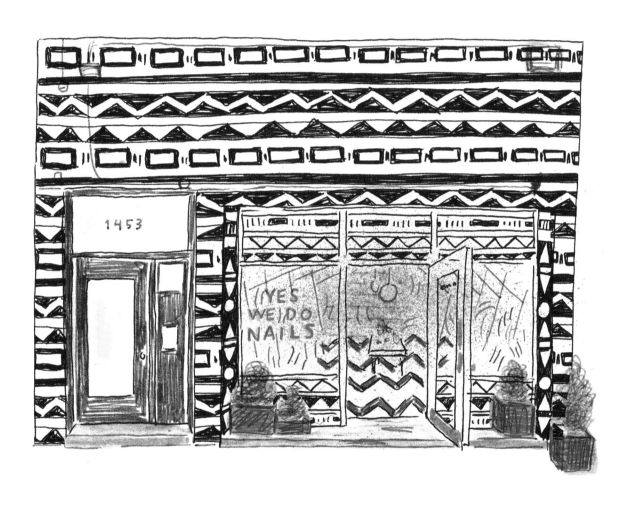

1453 Bedford Ave.
Crown Heights

Marché Rue Dix

———

Nilea Alexander, the owner of this concept store, has been on a mission to connect Brooklyn to her Senegalese roots. In 2013 she and her husband opened a Senegalese and French restaurant, Café Rue Dix, in Crown Heights. When the space next door became available, she took it over and began expanding her offerings in more ways than one. "Yes we do nails," the storefront's window proclaims—a clarification that becomes necessary when you learn this shop also offers vintage items, artisanal products from Senegalese artists, as well as coffee, tea, and hot sauce. Nilea has embraced the phrase, developing her very own line of vegan and cruelty-free nail polish, called Yes We Do Nails and available in forty-five different colors.

Marché Rue Dix has cultivated a devoted fan base, boasting over fifteen thousand followers on Instagram.

Its page features images of the store's latest artisanal jewelry and clothing imported from Senegal, as well as snaps of fresh animal-print and jewel-encrusted manicures. Nilea acknowledges that her products and services are eclectic but attributes her success as a business owner to this unpredictability. "I don't try to follow any specific calendar or any rules that have been set forth by the industry simply because I'm a small store and I get to create and drive that concept," she told the online magazine Shoppe Black. "I do what feels good to me."

Antojitos Ecuatorianos

3398 Fulton St.
Cypress Hills

Regulars say this Ecuadorian spot rivals some of the corner eateries you'll find serving up the nation's traditional fare in Quito. The *bolones*—fried balls of green plantains stuffed with cheese or meat—are a favorite. There's also a Bushwick location.

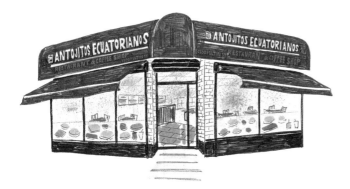

Roy's Custom Tailor

1261 Union St.
Crown Heights

If you're lucky, Roy Hudson, the owner of this neighborhood staple, will treat you to a Dizzy Gillespie history lesson while he alters your suit or fixes your zipper.

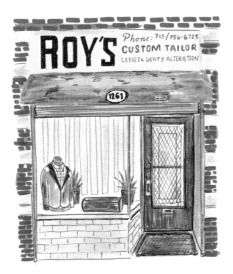

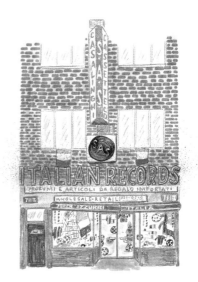

7113 18th Ave.
Bensonhurst

S.A.S. Italian Records

In the market for Italian-flag boxing gloves? Look no further than this shop, which Ciro and Rita Conte opened in 1967. Though it originally sold just records and magazines, in the ensuing years it's expanded to carry Italian sports memorabilia, movies, beauty products, and more.

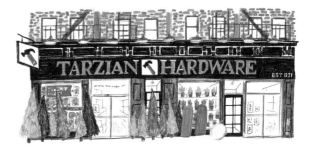

193 7th Ave.
Park Slope

Tarzian Hardware

Family-run hardware store Tarzian has been offering home-repair and gardening supplies to the Park Slope community since 1921. As dozens of online reviews attest, no matter how odd or specific your hardware needs, Tarzian will somehow have it in stock.

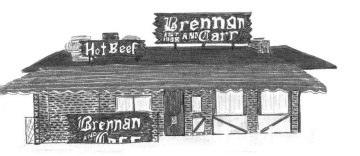

159 7th Ave.
Park Slope

Little Things Toy Store

—

Open since 1977, this store is stuffed with games, crafts, puzzles, dolls, and more. Don't know what to get the young human in your life? Ask for a recommendation from the staff, who will then wrap it up for you, compliments of the house.

3432 Nostrand Ave.
Sheepshead Bay

Brennan and Carr

—

George Brennan and Edward Carr opened this restaurant in 1938; today it's helmed by Eddie Sullivan, who has been running the place since the 1970s. Roast beef is the main draw, but the hot dogs and blueberry pie are close seconds.

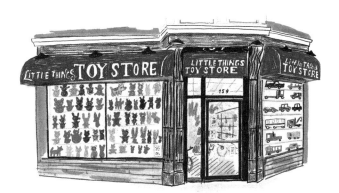

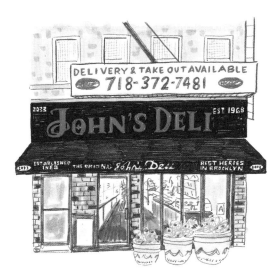

636 Washington Ave.
Prospect Heights

Natty Garden

—

Opened in 2008, this plant nursery caters to both experienced gardeners and those aspiring to green-thumb status, offering a wide variety of plants, seasonal gardening support, and landscape design. There's a second location in Bed-Stuy.

2033 Stillwell Ave.
Gravesend

The Original John's Deli

—

The pride and joy of this family-run neighborhood deli is the Johnny roast beef sandwich, completed with a rich gravy that has kept regulars coming back for more since the storefront opened in 1968.

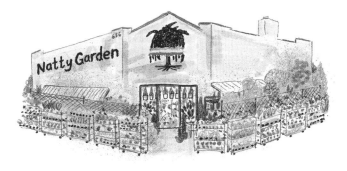

Wheated

———

Married couple David Sheridan and Kim McAdam opened this pizza shop in 2013, featuring a menu of pies named after Brooklyn neighborhoods. "Brighton Beach"—topped with garlic, black pepper, and bacon—is a local favorite. The pizzeria also offers an impressive by-the-shot whiskey menu, with hundreds of options. During the early days of the 2020 coronavirus pandemic, David and Kim sold off bottles from their whiskey collection to help raise funds for their employees.

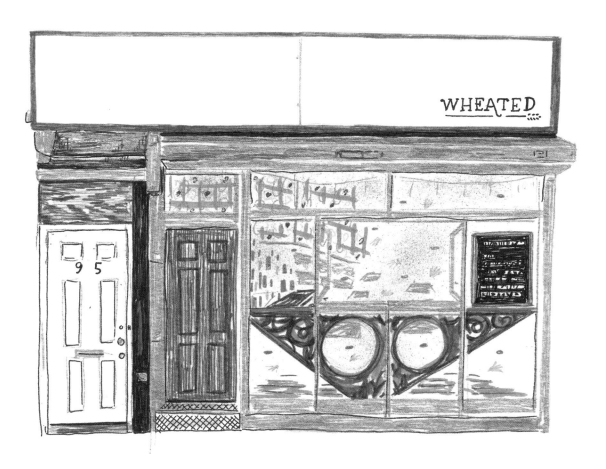

Tom's Restaurant

———

Opened in 1936, this old-school diner has made a name for itself not just for its longevity but also for its free samples. The popular restaurant is only open through lunch, and regulars begin to line up in the wee hours on weekend mornings. To help placate customers while they wait, servers walk the line doling out free sausage, ham, fruit, and cups of coffee. Despite the wait, in 2022 Eater listed Tom's among fifteen brunch spots to plan a weekend around. (And once inside, be sure to get the pancakes—the go-to menu item for regulars.)

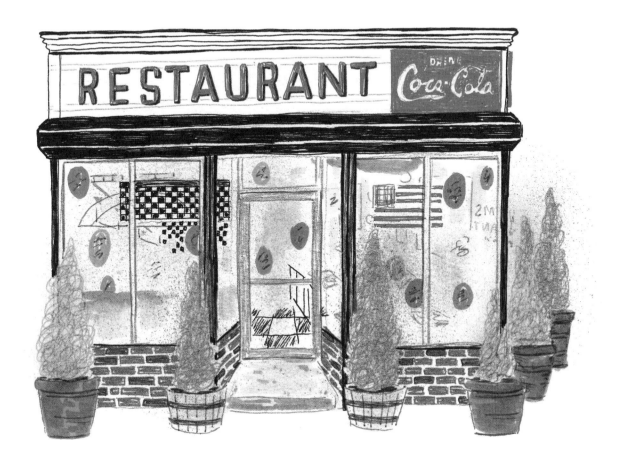

1027 Flatbush Ave.
Flatbush

Kings Theatre

The architecture duo Rapp and Rapp built this regal space in 1929. Originally outfitted with thirty-six-hundred seats, it was one of five ostentatious "Wonder Theatres" opened by Loew's Theatres at the beginning of the Great Depression. Amazingly, all five are still around, and all but one (the Valencia in Queens, which is now a church) are still entertainment halls.

In designing Kings Theatre, the Rapps took inspiration from the Palace of Versailles and the Paris Opera House—in other words, the interior sports a healthy dose of gold.

Kings Theatre operated as a movie palace and live vaudeville venue until it closed in 1977. Over the years many tried and failed to revive it, including former basketball player Magic Johnson, who once attempted to turn it into a twelve-screen movie theater. In 2015, after sitting empty for decades, the City of New York (which had taken over ownership of the building in 1979) renovated and reopened it as a performing-arts venue—with none other than Diana Ross headlining the grand opening concert. The update restored the space's ornate ceilings and woodwork, decades-old lobby furniture and drapes, and chandelier lighting. Today it's a favorite touring spot for musicians that have included the Flaming Lips, Janelle Monáe, and Ed Sheeran.

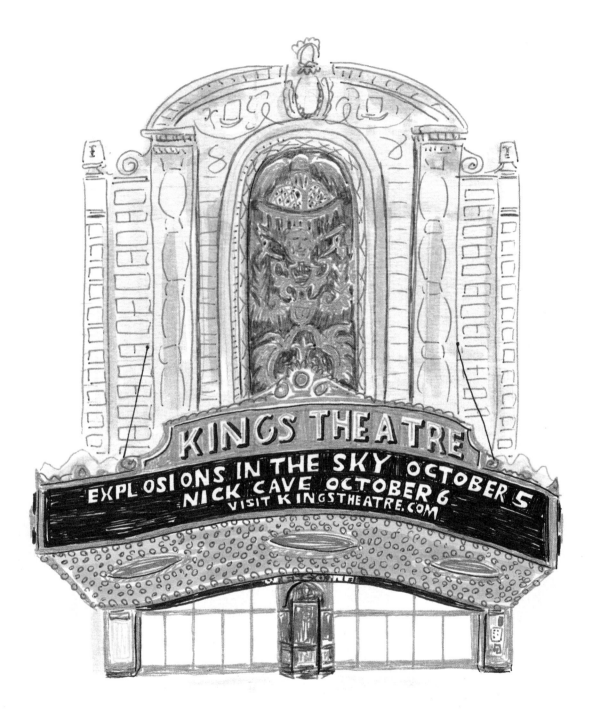

80 Lafayette Ave.
Fort Greene

Mo's Bar

—

Neighborhood watering hole Mo's became the site of an election-night celebration in 2008 following the victory of Barack Obama, the first Black president. Though the original spot, called Moe's, closed in 2011, the new owners slightly modified the name in tribute to the beloved bar.

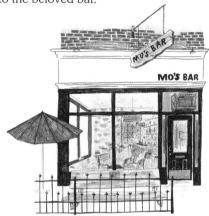

7801 15th Ave.
Bensonhurst

Romeo Bros. Meats

—

This butcher shop, which first opened in 1955, serves some of the best meat you'll ever "slap on your tongue," according to one online reviewer. It also sells to hundreds of local restaurants and food retailers.

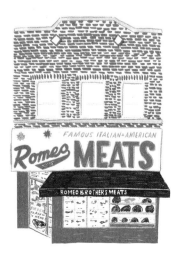

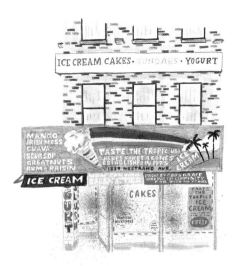

1839 Nostrand Ave.
Flatbush

Taste the Tropics USA

—

This family-owned ice cream shop opened in 1979 with the goal of infusing their scoops with Caribbean flavors. Today the list includes six signatures: vanilla, greatnut, mango, rum raisin, rummy nut, and coconut, all made from ingredients sourced from the tropics.

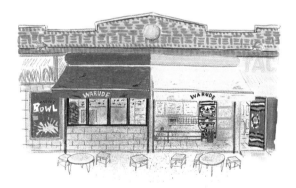

385 Tompkins Ave.
Bedford-Stuyvesant

WARUDE

—

Husband-and-wife team Yuichi and Hiroko Iida opened this fusion restaurant, which offers an eclectic menu of Japanese bowls and tacos, in 2018. As one online reviewer put it, dining here is "a vibe," with bustling communal tables and bright neon lights.

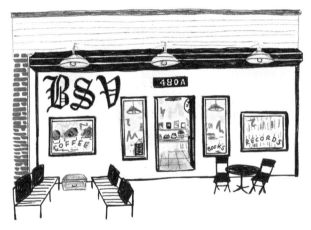

480A Madison St.
Bedford-Stuyvesant

Black Star Vinyl

Black Star is part record store, part community center. Stop in for some rare vinyl and first editions, but stay for coffee, to shop for clothes, or to listen to live music.

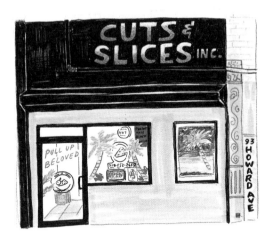

93 Howard Ave.
Bedford-Stuyvesant

Cuts & Slices

This pizza shop, which Randy Mclaren opened in 2018, fuses its slices with traditional Jamaican and Southern toppings like jerk shrimp, a variety of oxtails, and even chicken and waffles.

3924 3rd Ave.
Sunset Park

Frankel's

This family-owned business has been supplying the "working man" with the clothes needed "to get the job done" since 1890, according to its website. The store's current owner, Erik Frankel, represents the fourth generation to operate it.

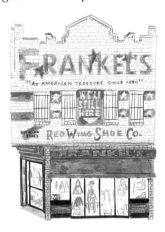

76 N. 4th St.
Williamsburg

McNally Jackson

Sarah McNally founded her independent bookstore in 2004 on Prince Street in Manhattan. While dozens of similar businesses have closed over the years due to competition from online retailers, she has instead managed to expand her empire, which now includes this Williamsburg location, along with four others.

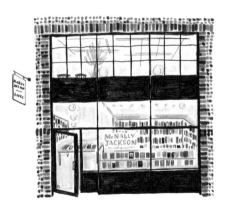

Shipwreck Seafood Boutique

This fishmonger sells thirty to forty varieties of its daily catches, in addition to its legendary fry platters and lobster rolls. Owner Joey Lugo makes a point of knowing each of his customers by name. "This is our *Cheers*," he said in an interview with BK Reader—one of few he grants, he explained, because he wants to ensure his business caters mostly to locals. "We're not here to do anything else but take care of our families and our neighborhood and our community, that's it," he said. "Nothing else matters." One of the ways he stays true to this ideal is by offering free seafood to seniors and others in need each week.

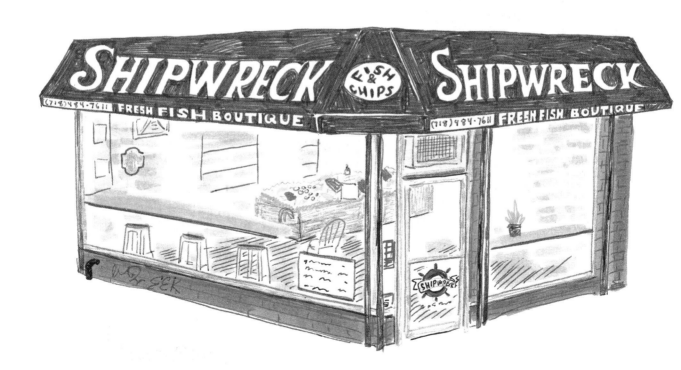

peace & RIOT

———

Interior designer Achuziam Maha-Sanchez opened this eclectic shop in 2013 with the money she earned from working on a major client's two-bedroom apartment on Central Park. The home-goods store has everything you need for a fresh start in a new pad, including furniture, kitchenware, and an energy-cleansing kit filled with lavender, quartz crystal, and palo santo wood.

The shop's name is derived from the name of a band that Achuziam and her husband, Lionel Sanchez, were part of prior to opening the business—the vibe of which continues in their store. "Our shop is where worlds collide," Achuziam told *Essence*, "where neighbors find each other and every now and then we put out some cucumber lemonade and eat together."

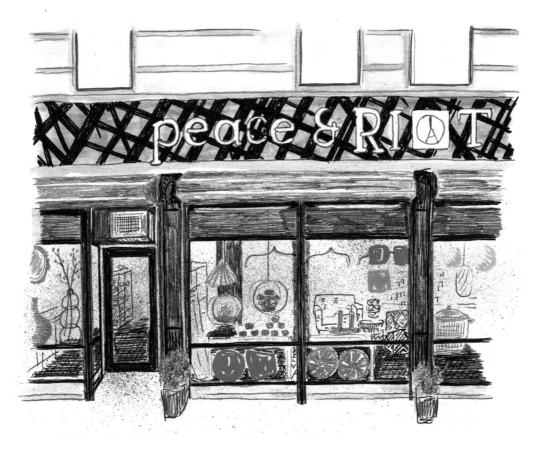

Staubitz Market

This Cobble Hill meat market was opened in 1917 by John Staubitz, and today it's the oldest still-operating butcher shop in all of New York. The spot maintains much of its century-old charm, including its original tin ceiling, marble counters, and sawdust-covered floors.

In 2023 the city's Department of Buildings issued current owner, John McFadden Jr., an emergency decree to fix Staubitz Market's rear facade, a project with an estimated cost of $125,000; closure seemed likely. Fortunately, John's loyal customer base—who continue to shop at the family-owned business despite challenges from online retailers and big-box grocery stores—helped raise the funds to renovate it.

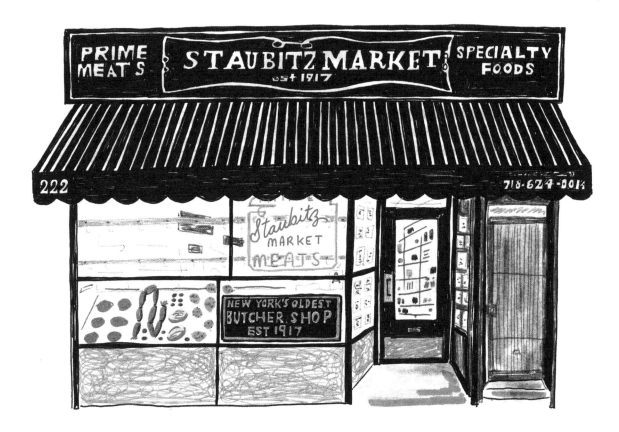

Keur Djembe

Ibrahima Diokhane opened this shop in 1998, aptly naming it "House of Drums" in his native Wolof, a West African language. His storefront overflows with drums of various sizes, most of which are made from materials he sources from his home country of Senegal.

Ibrahima fell into the business by accident. He'd often bring along a drum to help pass the time while vending clothes on the streets of Brooklyn. As it turned out, passersby were much more interested in his handcrafted musical instruments.

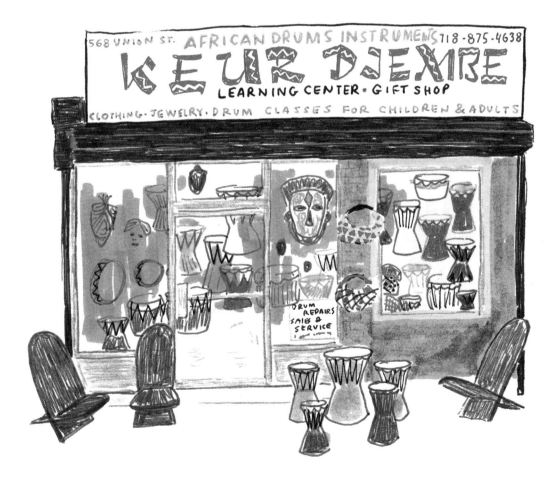

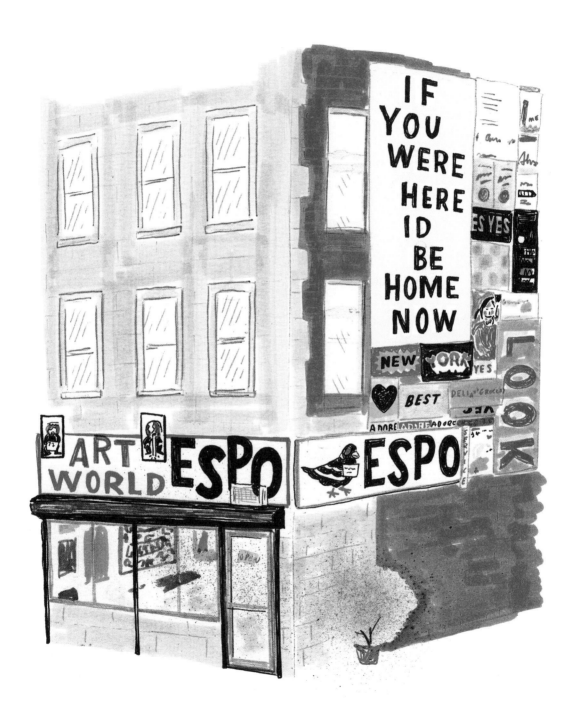

ESPO's Art World

———

It was hard to miss Stephen Powers's vibrant storefront, located on Fourth Avenue and Bergen Street and closed in December 2023, thanks to the bold, colorful designs that decorated the building—and gave a hint of what was inside. Stephen got his start tagging the moniker ESPO (which stands for "Exterior Surface Painting Outreach") throughout the streets of New York City and Philadelphia in the 1980s and 1990s. He was apprehended for vandalism in 1999. Many suspect the arrest was retribution for the role he played that year in protesting Mayor Rudolph Giuliani's attempts to censor the Brooklyn Museum's exhibition *Sensation*, which featured artworks by several Young British Artists, a loose collective known for their unusual mediums and methods. As part of the protest, Stephen and others threw fake elephant poop at a drawing he made of Giuliani. "I pled guilty only because I was," Stephen told Politico in a 2012 article about the event.

During the 2000s Stephen transitioned from street graffiti to a career as a mural artist and sign painter, founding this storefront and studio to house both his original and commercial work.

The switch paid off: he has since exhibited at the Venice Biennale, received a Fulbright scholarship, and completed mural commissions in cities all over the world.

While he may no longer be tagging the streets of New York, Stephen's work continues to be subversive and political. In 2017 he created nine animated illustrations for a series of *Vogue* articles on gun violence, employing words that survivors used to describe those killed in shootings.

1082 Nostrand Ave.
Prospect Lefferts Gardens

Culpepper's

—

Opened in 1998, this Barbadian restaurant specializes in the country's national specialty: *cou-cou* with flying fish—a meal the *New York Times* once described as "absolutely humongous." It includes cornmeal and a tomato and onion–based sauce.

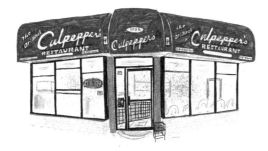

7803 15th Ave.
Bensonhurst

Lioni Italian Heroes

—

This sandwich shop sources ingredients from Lioni Latticini, the Salzuro family's related cheese-making business with a store just down the block. The Salzuros started making cheese over a century ago in Lioni, Italy, and today they are one of the biggest distributors of fresh mozzarella in the US.

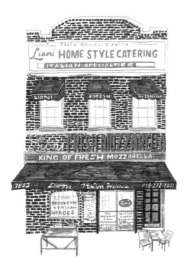

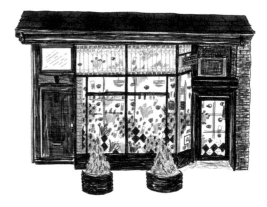

1118 Cortelyou Rd.
Ditmas Park

Sycamore Bar + Flower Shop

—

While picking up a bouquet at this flower shop, why not stay for a drink? The bar-florist combo boasts a menu featuring seventy-five types of bourbon and other whiskeys.

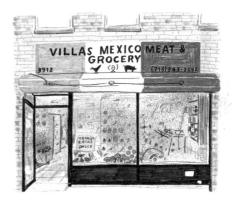

3912 Ft. Hamilton Pkwy.
Sunset Park

Villas Mexico Meat & Grocery

—

This Mexican meat market and grocery store is the place to pick up Jarritos flavored sodas, Jumex fruit drinks with pulp, and "any cut" of meat you could want, according to one online reviewer.

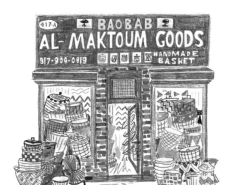

417-A 7th Ave.
Park Slope

Al-Maktoum Goods

Aliou Lo, who is originally from Senegal, blends traditional weaving techniques with modern influences to create one-of-a-kind baskets, textiles, and other home goods. Though his storefront closed in 2023, his handmade, fair-trade products are still available through the business's website.

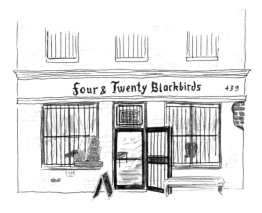

439 3rd Ave.
Gowanus

Four & Twenty Blackbirds

Melissa and Emily Elsen opened this storefront to house their bakery business in 2010. The sisters focus on making pies in a "truly handmade way," using seasonal and locally sourced ingredients. According to regulars, the salty honey pie is a must-try.

328 DeKalb Ave.
Clinton Hill

Mike's Coffee Shop

Despite its name, this spot, which first opened its doors in the early 1950s and still sports a framed 1986 *Daily News* review, is much more than a coffee shop. Regulars swear by the chicken and waffles and pancakes.

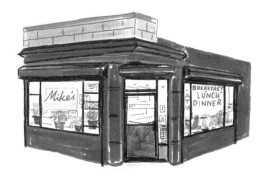

461 37th St.
Sunset Park

Melody Lanes

In a classic art-imitating-life moment, this bowling alley, which has been open since 1958, has been a regular haunt for actors Steve Buscemi and John Turturro—who will forever be associated with the sport thanks to their starring roles in *The Big Lebowski*.

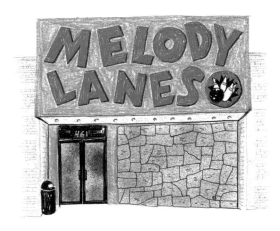

Kellogg's Diner

———

Open since 1928, this classic diner is often busiest in the wee hours, when people pop by to cap off an evening of partying. In early 2024, new owner Louis Skibar (of Coppelia fame, in Manhattan) and chef Jackie Carnesi (from Greenpoint's Nura) updated the century-old spot by adding a cocktail bar and some Tex-Mex dishes to the menu.

Kellogg's has served as a location for many movies and television shows, including HBO's *Girls* and CBS's *Person of Interest*, injecting them with a dose of Brooklyn-esque authenticity. Makeup maven Pat McGrath once chose the space to create what *Vogue* called a "club-kid paradise" to celebrate a new product launch.

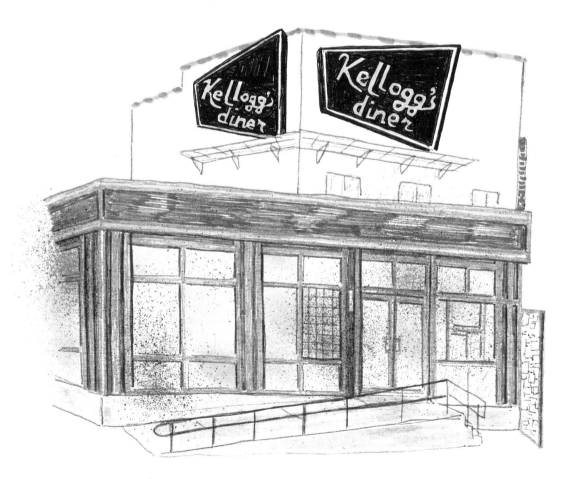

Eugene J. Candy Co.

———

Describing itself as a "most peculiar" candy store, this Halloween-themed spot in Bushwick sells confectionary, chocolates, novelty items, and more, "with a dash of macabre"—like bloody gummies resembling body parts. The owner, who refers to himself as Eugene J., is a chemical engineer turned evil Willy Wonka. He got his start in the sweets business in Berlin, where he would sell his wares out of a briefcase to frustrated clubgoers desperate to get into the notoriously fussy Berghain. Today he continues to innovate new treats in his lab at the store, hidden behind a *Wizard of Oz*–type purple curtain.

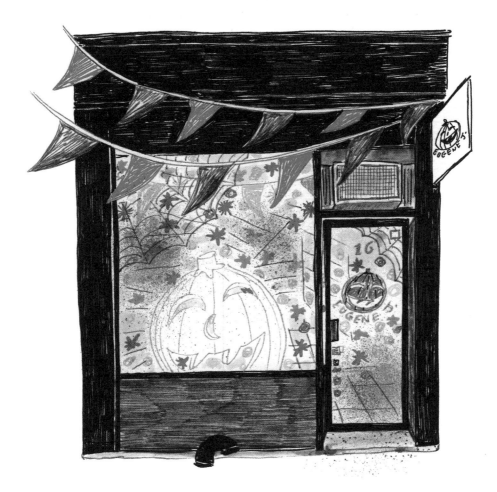

145

BLK MKT Vintage

———

Kiyanna Stewart and Jannah Handy have always loved a good vintage store but couldn't find one in New York that reflected their cultural experiences. Speaking with the *Today* show, Kiyana recalled childhood memories with her mother, "going into antique shops [and being] the only Black people in the spaces." She noted that they never found Black-made art on the walls, nor saw many Black authors on the bookshelves.

The couple decided to take to the road, traveling across the country to find Black art, literature, and other artifacts. Upon returning to New York in 2014, they started selling their collection at various flea markets and stoop sales but outgrew these venues as demand for their wares increased. In 2019 they decided to open their very own store, which they intended to serve as a "curated love story . . . rooted in our love for Black people, Black culture, and our own lived experiences," according to their website.

On any given day at BLK MKT Vintage, you may find a "Mandela: Free at Last!" T-shirt from the 1990s, an original Spike Lee *Do the Right Thing* postcard, or rare vintage covers of *Jet* and *Ebony* magazines.

Much more than a brick-and-mortar storefront, BLK MKT Vintage provides interior design services, prop rentals for movie and television sets, and exhibition spaces, among other offerings, all celebrating Black culture. "Not only do we see you, but we love you as well," the duo proclaims on their site. "You're worthy. What you've created is worthy. You are important here."

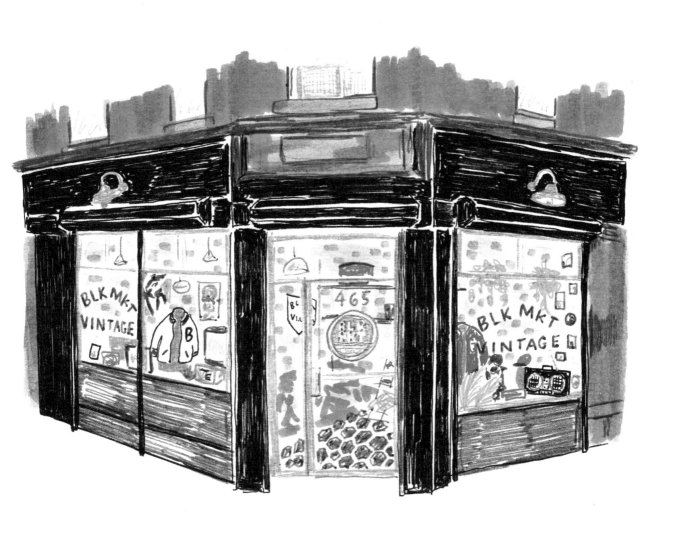

Risbo

———

Chef Boris Ginet opened this fast-casual roasted-meats restaurant in 2016, drawing inspiration from the relaxed café culture he was used to growing up in Paris. As the *New Yorker* said in a review, it can be hard to distinguish the staff from customers among the "young, hip, diverse crowd."

Unsurprisingly, the menu perfectly matches this leisurely vibe. In addition to their staples, such as rotisserie-cooked chicken, pork, lamb, fish, and duck, it features a section called "Whatever," an eclectic array of offerings that may include the likes of deviled eggs, tacos, and mac and cheese.

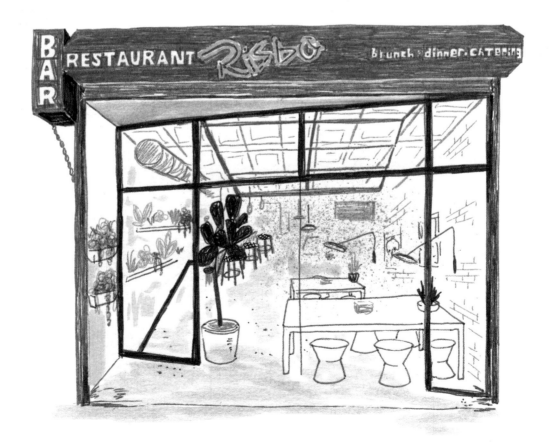

Nitehawk Cinema

These days, many movie theaters in New York City offer fancy cocktails and restaurant-grade food items. But Nitehawk Cinema started the trend in 2011 with its first location, in Williamsburg, which was the first movie theater in the state with a liquor license. This spot in southern Park Slope opened in 2018 in the former 1920s-era Pavilion Theater.

Though Nitehawk may no longer be the only place in town where you can enjoy an adult beverage while taking in a film, the theater remains in a league of its own. As part of its Film Feasts series, they offer food and drinks inspired by the titles they're showing. While screening the Sweden-based horror flick *Midsommar* in the summer of 2023, for instance, the venue served rabbit meatballs and pork pies, paired with beer and a shot of Aquavit—all Scandinavian favorites. The drinks, naturally, were served during the film's scariest scene.

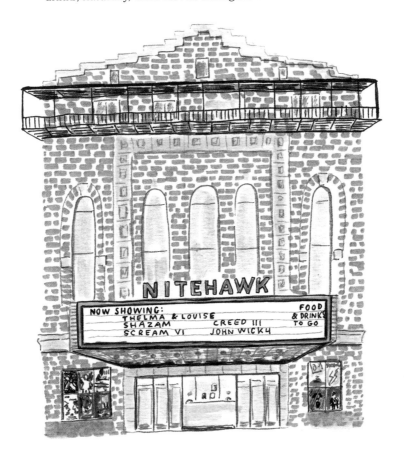

Roberta's Pizza

——

Opened in 2008 on the edge of East Williamsburg and Bushwick, this pizza spot—which *USA Today* once included in a list of the top fifteen pizza parlors in the United States—has a cult following dedicated to its brand of wood-fired pies. But Roberta's has always done more than pizza. Over the years, the venue has housed a rooftop garden, beehive, radio station, and the popular Tiki Disco dance party. Now they have multiple locations in the city and one even as far as California.

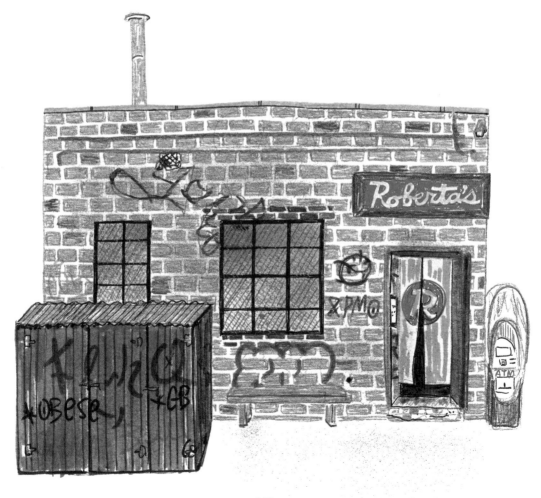

5th Avenue Records

———

Tony Mignone opened this record store in 1966, and it's still going strong despite rising Park Slope rents, fierce online competition, and near-constant rumors of closure. If lovers of music memorabilia have any say in the matter, the shop will likely be around for years to come.

Here you can pick up hard-to-find old-school vinyl and tapes, as well as other throwbacks like VHSs, 8-tracks, and CDs. Today DJ Ryan Romanski, who also heads the Brooklyn-based record label Boss Trax, owns and operates the space. (The illustration, however, shows the shop while it was under Mignone's care.) In addition to the store's traditional offerings, like classic rock, blues, and jazz, Ryan has worked to expand into other musical genres—including industrial, metal, and electronic—with a particular emphasis on showcasing local Brooklyn talent.

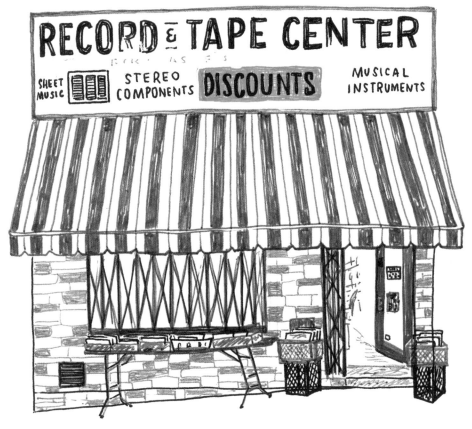

Convivium Osteria

Carlo and Michelle Pulixi opened this Italian restaurant in 2000 and began serving up classics like homemade fettuccine and more inventive dishes such as ravioli stuffed with green apple, ricotta, and cinnamon. The decor includes wooden tables and chairs, and copper pots and clay urns hang from the walls—an atmosphere that almost makes customers feel like they're dining in Carlo's native Sardinia. If you're lucky, you'll get seated in the catacomb-like basement.

Michelle, whose family hails from Portugal, has also left her mark on the restaurant, infusing the menu with heavy Iberian influences. As Frank Bruni once wrote in a *New York Times* review, "The pleasures for a carnivore on the Convivium menu are many," with a wide selection of cured meats, slices of pork loin, and chorizo.

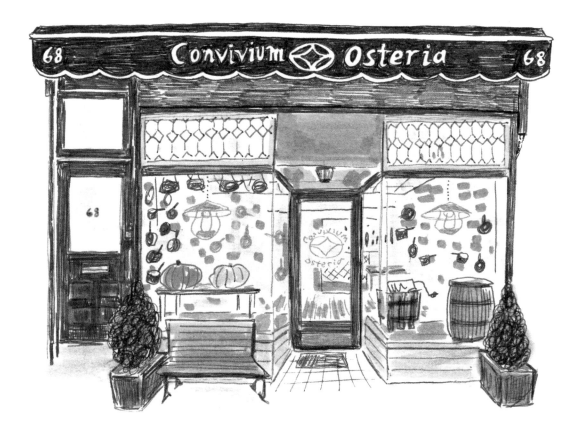

Bossa Nova Civic Club

———

John Barclay co-opened this club in 2012 with a mission to "stand in fierce defiance of the Cracker Barrelization and Portlandification of Brooklyn nightlife," according to an interview in *Fader*, where he also described the intended vibe as "techno *Cheers*." The small space, which can accommodate just 140 people, combined with consistently top-tier DJ bookings, means anxious ravers often must brave lengthy lines for a chance to dance atop Bossa's black-and-white-checkered floors. (The line became so iconic it inspired its very own Instagram account.) The beloved club suffered extensive water damage as the result of a fire in a nearby apartment building in early 2022 and might have closed were it not for the $113,000 raised via a crowdfunding campaign that helped its owners reopen.

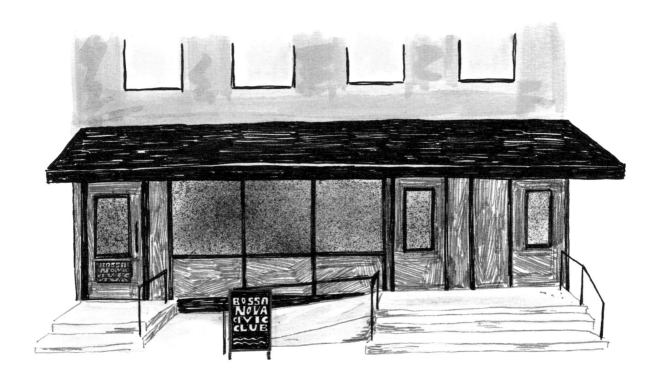

2901 Emmons Ave.

Sheepshead Bay

Roll-N-Roaster

———

If you've never eaten at this restaurant—the "not-so-fast" fast-food spot—then you're "wasting your life," according to Gothamist. Legions of Roll-N-Roaster fans would agree, and not just because of the diner's generous policy to offer guests free "cheez on anything you pleez."

A visit here is like taking a trip back in time; very little about the place has changed since Buddy Lamonica first opened its doors in 1970.

Much as they did decades ago, diners feast on the same roast beef sandwiches on the same yellowish Formica tabletops, lit overhead by the same bulbous chandeliers. Except for the prices, the orange-and-green-tiled menus—with offerings like a grilled chicken sandwich, a bottle of champagne, and something called a fried shrimp cup—haven't changed either.

But to the shock and horror of generations of devotees, one thing has unfortunately been modified: in 2022 the owners abruptly removed the restaurant's iconic cottage fries from its menu after their supplier discontinued them. (Despite a Change.org petition that gathered hundreds of signatures, the supplier was unmoved.) There has been one other major shift during Roll-N-Roaster's decades of tradition: the staff traded their fashionable berets for more sanitary baseball caps and hairnets. This update didn't seem to inspire the same level of passion, for some reason.

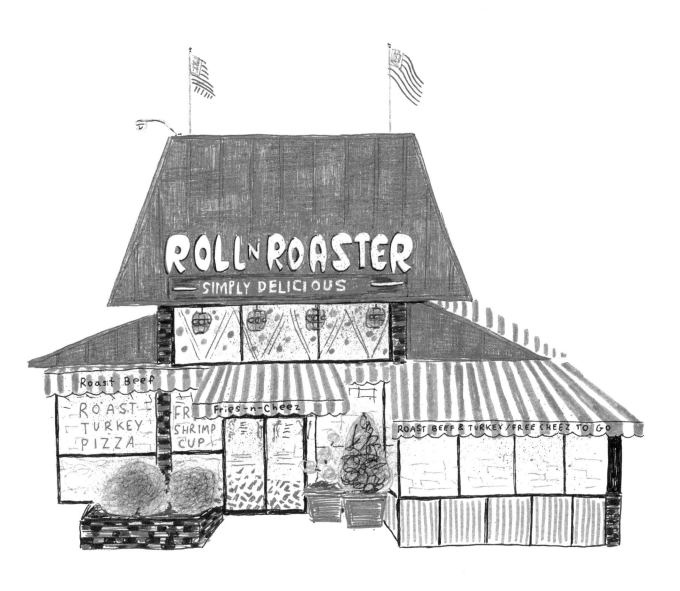

631 Manhattan Ave.
Greenpoint

Frankel's Delicatessen & Appetizing

—

Family-owned-and-operated Frankel's Deli has been serving up Jewish fare—with a special emphasis on smoked and braised meat, smoked fish, and fresh salads—to the Greenpoint neighborhood since 2016.

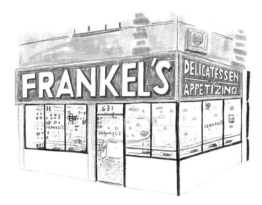

225 Smith St.
Boerum Hill

Books Are Magic

—

Drop into this independent bookstore on the right day and you might be serenaded by actor Channing Tatum reading his latest children's book to a crowd. (Bring a kid with you, otherwise it's creepy.) Owners Emma Straub and her husband, Michael Fusco-Straub, run a second location in Brooklyn Heights too.

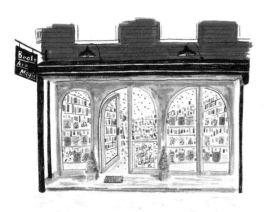

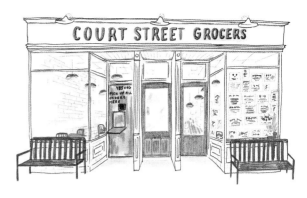

485 Court St.
Carroll Gardens

Court Street Grocers

—

Court Street Grocers is best known for its inventive breakfast sandwiches, which vary slightly at each of its four locations. Local offerings at this Carroll Gardens storefront, the original, include a broccoli Reuben, short rib kimchi, and salmon.

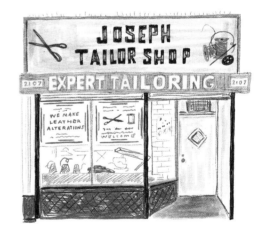

2107 E. 14th St.
Sheepshead Bay

Joseph Tailor Shop

—

This old-school Italian tailor turns around repairs and alterations at lightning-fast speed, according to regulars. And Joseph won't just take your money—if your item is beyond repair, he'll let you know it's not worth it.

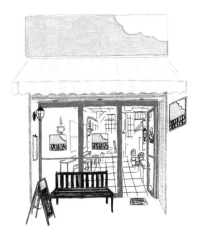

53 5th Ave.
Park Slope

Blue Sky Bakery

Blue Sky Bakery is known to many regulars simply as "the muffin place," and for good reason. The muffins here are inventive (including flavors like blueberry pumpkin and mango pineapple) and packed with fruit. Be sure to arrive early: the best muffins sell out by noon.

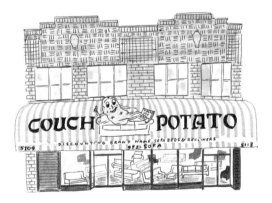

5109–5113 New Utrecht Ave.
Borough Park

Couch Potato

This store sells sofas, chaises, and other furniture—but is best known for the iconic potato mascot prominently featured on its awning, lounging away, as couch potatoes are wont to do.

1449 Broadway
Bushwick

Artist & Craftsman Supply

This employee-owned art-supply store has everything you need for your next craft project—and plenty of things you didn't know you need, like Jacquard cyanotype mural fabric and luminescent watercolors.

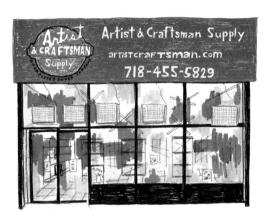

51 Buffalo Ave.
Bedford-Stuyvesant

Happy Cork

It makes sense that someone named Sunshine Foss would open a store with "happy" in the title. The shop, which she runs alongside her husband, Remo, has become a destination for those eager to sample from their large selection of Black- and minority-owned wines and spirits.

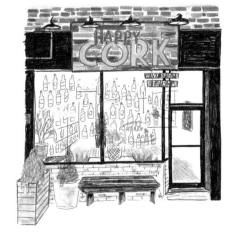

Three Decker Diner

———

This Greenpoint spot has operated as a diner since 1945. But in 2022 Gavin Compton, the owner of the Variety Coffee empire, and Eduardo Sandoval, the restaurateur behind local burger chain Blue Collar, took over the space. The new proprietors worked to keep Three Decker true to its original form, down to retaining the diner's regulars and entire staff. Of course, they have made some updates, like a liquor license that now allows customers to order a Bloody Mary at brunch. Still, this old-school diner is committed to offering the basics—serving roughly five hundred pounds of potatoes a week and up to four hundred cups of coffee a day, according to an online interview with the new owners.

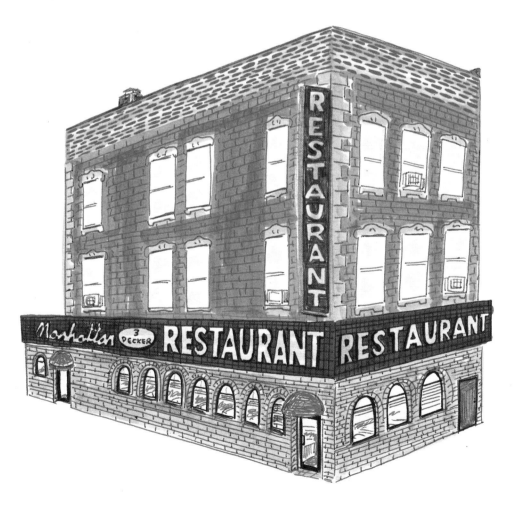

Paul's Daughter

———

One of the oldest still-operating Coney Island boardwalk joints, Paul's Daughter has been serving corn dogs, Italian ices, cotton candy, and more since 1962. The seafood here, though, is a favorite. As a 2023 review on the Infatuation put it, "Maybe it's just because we can see the ocean while we eat them, but their clams seem fresher and more expertly shucked than at the other spots."

Regulars also say the frozen margaritas, available in flavors like strawberry and watermelon, are a must during a hot summer day. Though they recently renovated the space, the owners of Paul's Daughter mercifully preserved the storefront's iconic rooftop figures, called Papa Burger and Burger Girl.

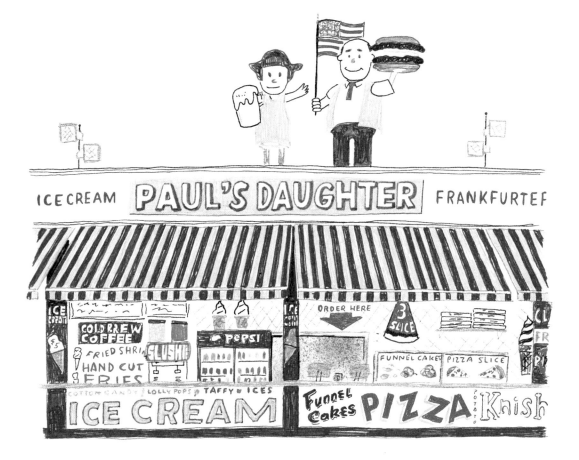

Junior's

———

Harry Rosen founded this restaurant in 1950, but his family had been in the diner business since 1929. Though the chain now includes several spots throughout the tristate area, the original is located at Flatbush and DeKalb Avenues. It continues to be a neighborhood institution that's become something of a required stop for politicians looking to connect with Brooklyn locals. Former President Barack Obama and Bill de Blasio, then running for mayor, chose Junior's as the spot for a highly publicized visit in October 2013 (Obama bought cheesecakes and a couple of black-and-white cookies). A 2020 *New York Post* article also revealed that US Senator Chuck Schumer spent $8,600 on cheesecakes here in less than a decade.

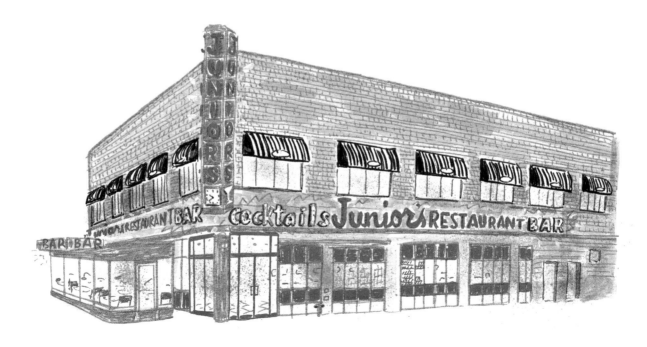

1524 Neptune Ave.
Coney Island

Totonno's

———

This landmark pizzeria has been slinging coal-fired brick-oven pies at the same Coney Island location since the 1920s—and claims to be the oldest continuously operating family-owned pizzeria in the country. Anthony "Totonno" Pero founded the restaurant after first starting to sell pizza in 1905 at Lombardi's (then a grocery store) on Manhattan's Spring Street, which is believed to be the first pizzeria in the US.

The century-old staying power of Totonno's isn't just thanks to this historic family lore, however. The slices here are also divine, at least according to Zagat. In a review, they wrote that "only God makes better pizza."

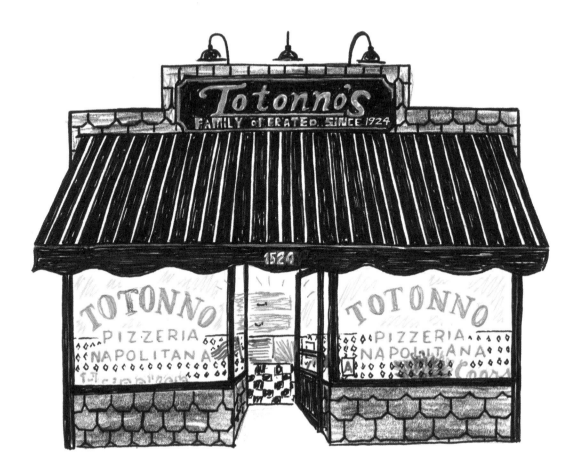

NORTHERN BK

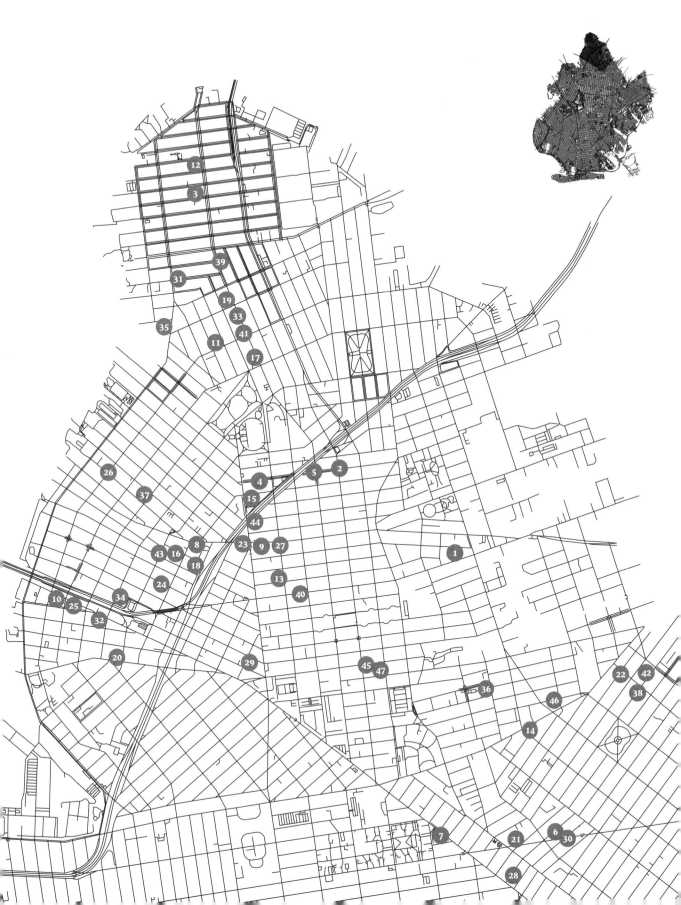

NORTHWESTERN BK

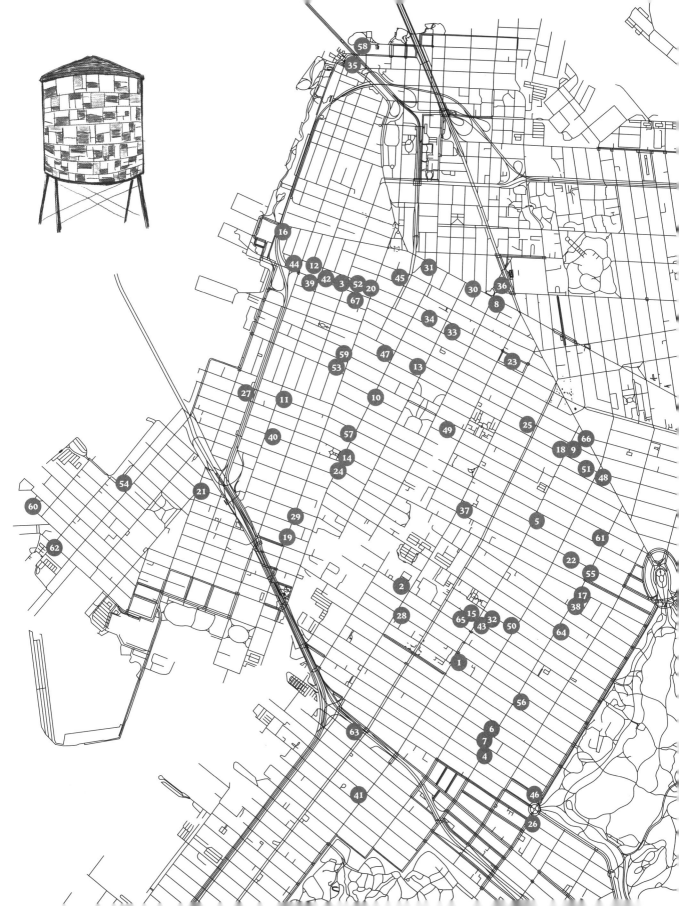

CENTRAL BK

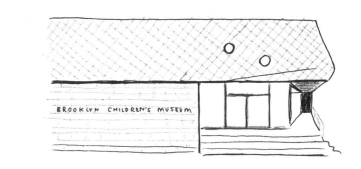

BROOKLYN CHILDREN'S MUSEUM

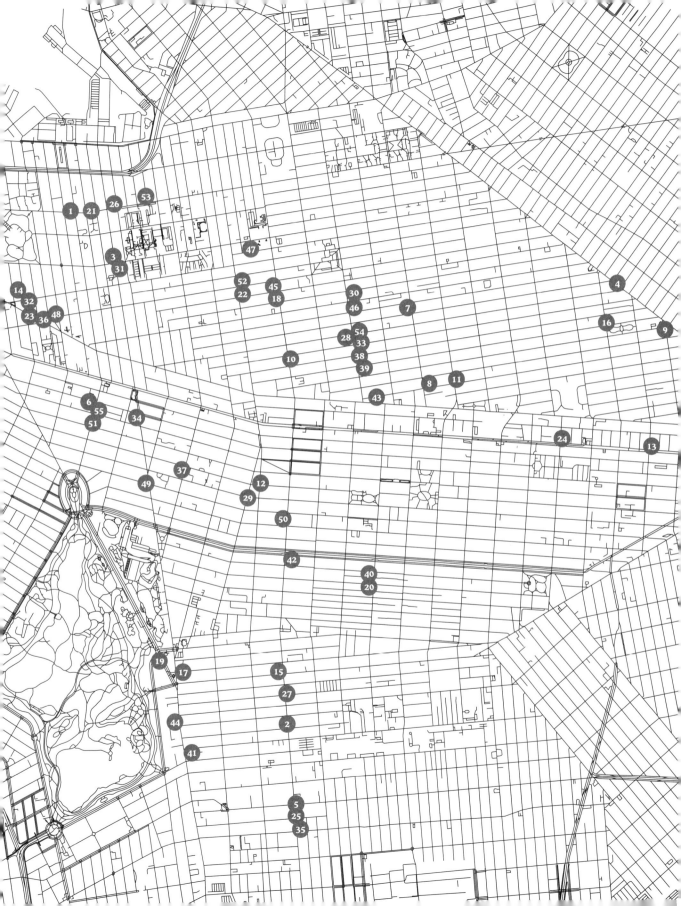

SOUTHWESTERN BK

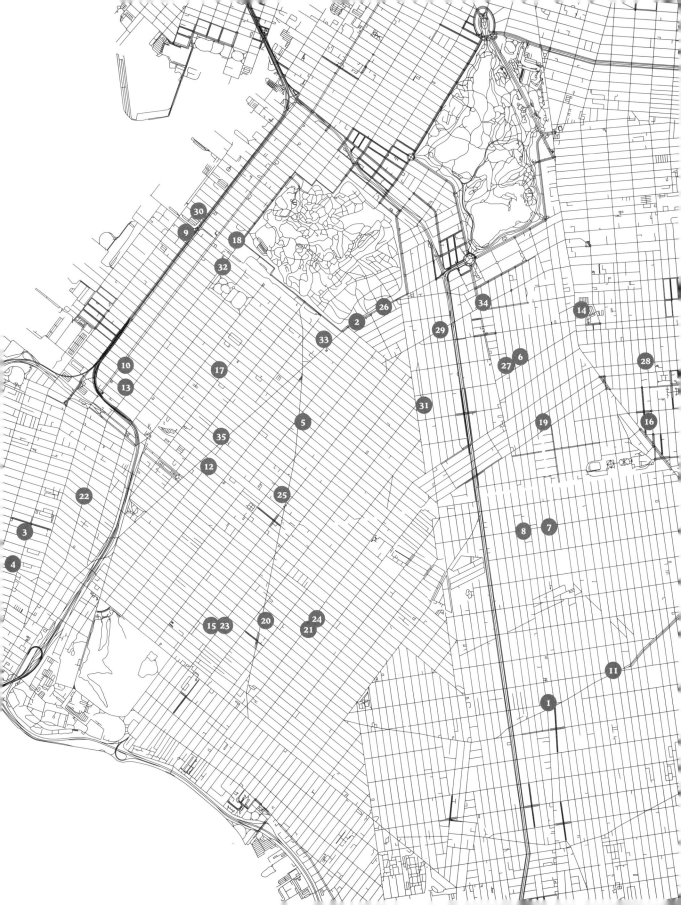

SOUTHERN AND EASTERN BK

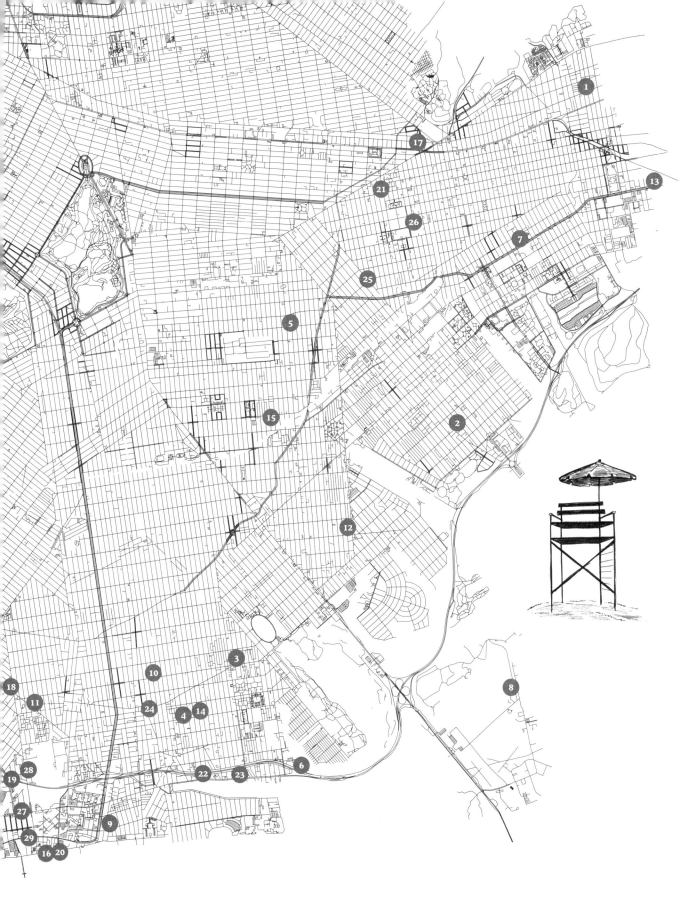

INDEX

BIOGRAPHIES

Joel Holland is an illustrator and hand-letterer whose work has graced the *New York Times*, the *New Yorker*, *New York* magazine, store windows around the globe, and numerous book covers. He lives in Manhattan with his wife and two daughters, where they can see the lights of the Empire State Building every night. His love of NYC started when he first moved to Brooklyn in 1998; nowadays you can often find him hanging out with friends in Prospect Park or picking up a slice at Smiling Pizza. He is the author of two previous books, *NYC Storefronts* and *London Shopfronts*, both published by Prestel. Follow him on Instagram @joelholland_studio.

David Dodge is a freelance writer living in New York City who covers travel, LGBTQ stuff, health and wellness, politics, culture, and more. He is a frequent contributor to the *New York Times* and has had work appear in outlets including *CN Traveler, Travel + Leisure, Newsweek, USA Today*, and more. His previous books include *Sassy Planet, NYC Storefronts*, and *Category Is: Cocktails!*, all published by Prestel. He lives in Manhattan—and apologizes for that joke he made about Brooklyn in the bio from his first book.

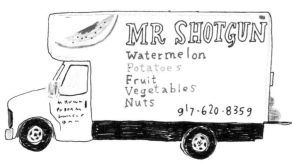

ACKNOWLEDGMENTS

JOEL HOLLAND

As the Notorious B.I.G. once said, "*Spread love, it's the Brooklyn way!*" That's why we are here. This book wouldn't be possible without the friends and family who helped along the way. As always, I have to acknowledge the love and support of my home team: my wife, Ploy, and our daughters, Ella and Nina. Their tolerance for trying new places and stopping to take pictures has been infinite! Also, my parents, Blaine and Judy, for reminding me how special all of this is. And my brother Stan and his family, my sister-in-law May and hers, and my mother-in-law, Mallika. THANK YOU!

Additionally, a THANK YOU to my pals for all their tips. Megan Hackett, Matthew Dolven, Ariella Papa, Mike Greaney, Joseph and Vanessa Setton, Michelle Willems, Craig Yoskowitz, Michelle Andrews, Seth Nemeroff, Jesse Vozick, Jennifer and Maryann Prezioso, Pritsana Kootint-Hadiatmodjo and Ari Hadiatmodjo, Roman Grandinetti, and Carol Hayes.

Thank you to Ali Gitlow for once again making dreams come true. Thank you to David Dodge for the thrill of reading your words. Thank you to Alex Stikeleather for your incredible design—I'm still giddy from the first one, and now there are three beauties! Thank you to copyeditor and proofreader Michael Ferut for keeping us in check very thoroughly! And finally, thank you to the entire Prestel team. I appreciate all you do to make this what it is. As the old bodega bags used to say, "THANK YOU THANK YOU THANK YOU."

DAVID DODGE

First, a hearty thanks to the owners of Brooklyn's small businesses. So many of these spaces double as community institutions whose worth to the surrounding neighborhood extends far beyond simply what they sell. This includes places like Park Slope's String Thing Studio, which transforms itself into a free knitting and crochet circle on occasion, and Paperboy Prince Love Gallery, whose owner has helped raise and distribute millions of dollars' worth of food to those in need across the city.

I'm afraid I owe the good people of Brooklyn (all 2.5 million of you) an apology. Though I've lived in Manhattan for over twenty years, I figured I'd still be familiar with the vast majority of the storefronts suggested for inclusion in this book. After consulting with trusted Brooklynites, including Ifeoma Ike, Sondra Youdelman, Emma Zurer, Harish Bhandari, and Suzanne Shapiro, this assumption quickly proved to be false. Thank you to these friends for helping ensure the book does a much better job reflecting the depth and diversity of Brooklyn's businesses than I could have done on my own. I have a long list of restaurants and stores I'm excited to visit now thanks to your suggestions, and I look forward to dazzling my Brooklyn-based friends with factoids, history, and lore about their favorite local institutions.

Thank you, of course, to Joel Holland for allowing me to bring some context to his beautiful drawings—the collaboration was just as fun, easy, and seamless as our first, *NYC Storefronts*. Thanks a million to our editor, Ali Gitlow, for the opportunity to collaborate with Joel once again. Thanks to Ali and Michael Ferut for your careful and thorough copyedits—the book is much stronger and better written due to your efforts.

© Prestel Verlag, Munich · London · New York, 2024
A member of Penguin Random House Verlagsgruppe GmbH
Neumarkter Strasse 28 · 81673 Munich

© for the illustrations: Joel Holland, 2024
© for the text: David Dodge, Joel Holland, and Kimberly Drew, 2024
© for the map base: Adobe Stock/Momcilo

Library of Congress Control Number: 2023950882

A CIP catalogue record for this book is available from the British Library.

Editorial direction: Ali Gitlow
Copyediting and proofreading: Michael Ferut
Design and layout: Alex Stikeleather
Production management: Luisa Klose
Separations: Reproline Mediateam, Munich
Printing and binding: DZS Grafik, d.o.o., Ljubljana
Paper: Magno Natural

Penguin Random House Verlagsgruppe FSC® N001967

Printed in Slovenia

ISBN 978-3-7913-9110-6

www.prestel.com

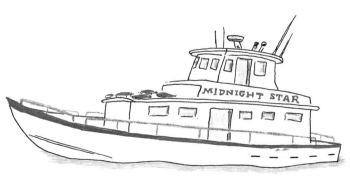